ICONS

50 heroines who shaped contemporary culture

Illustrated by Monica Ahanonu · Written by Micaela Heekin

table *of* contents

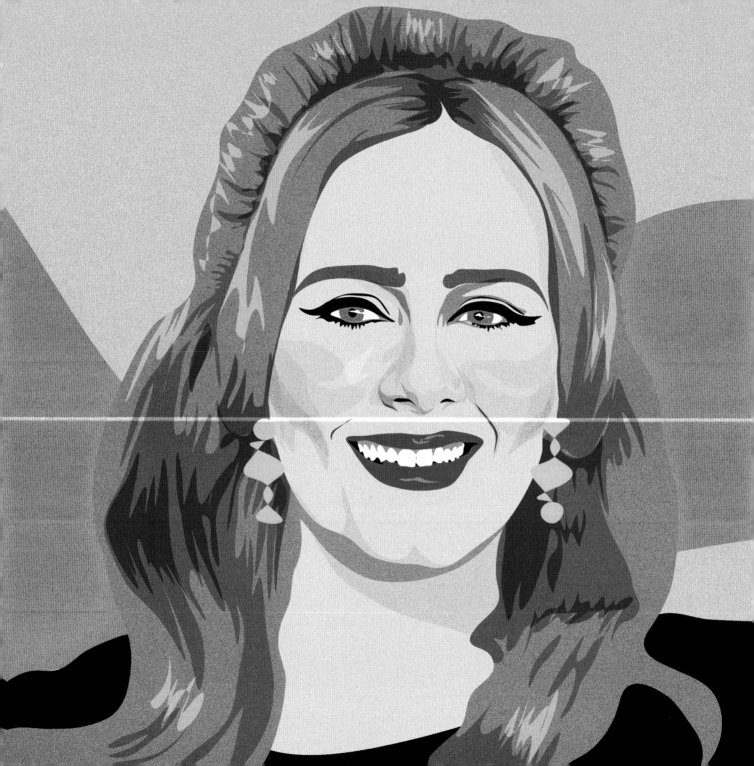

ADELE

Adele is a reluctant diva. Her talent and her success have made her a household name in the truest sense—no last name needed. Yet when she says she "never in a million years thought this would happen to me," it's utterly believable. Adele Adkins was raised between North London and Brighton, and she claims to still be worried that she's on a hidden camera show, and soon someone will come to tell her it's time to go back to Tottenham.

A couple of topics come up over and over again when Adele speaks to the press—she talks about becoming a mother, her crippling stage fright, the pitfalls of fame, and the revelation that came when she began writing songs. The one thing she doesn't talk too much about is her voice. Listening to Adele sing feels like riding a rollercoaster; she swirls and dips and soars, and just when it feels like you might leave the earth entirely, she swoops back down to leave you breathless and wondering, What just happened? And yet, to Adele, it's just her voice.

That said, she definitely doesn't take caring for it for granted—she was devastated to have to cancel shows at Wembley Stadium in London when she learned she'd damaged her vocal cords and needed surgery to repair them. She couldn't speak, let alone sing, while she recovered. So she is careful with her voice, and she worries about it. But the how or the why of it,

where did that sheer beauty and brilliance of sound come from? Radio silence.

Adele signed with XL recordings after graduating from school, and she released *19* two years later. *21* and *25* followed, each album more shockingly successful than the last. Prince Charles awarded Adele the MBE in 2013 for services to music, and her albums are some of the best-selling of all time. But still, she says, "My career is not my life. It's my hobby." She eschews anything that might garner her "more"—more fame (openings and events), more money (she says she'll never be "the face of" such and such a fashion house). Instead Adele relishes the private life she has maintained while rocketing to fame. It's a retreat from the frenzy of celebrity, and a way to stay in touch with how regular people live. "How am I supposed to write a record that people can relate to if I'm doing unrelatable things. It's impossible."

While she protects her reality for the sake of her sanity and her songwriting, Adele says her ability to compose songs that touch so many people remains somewhat mysterious to her. She claims not to have a gift for language when she's speaking, but says her "head comes alive" when it's time to write music. Whatever it is she does to compose the likes of "Hello" and "Rolling in the Deep," let's hope she keeps doing it for many years to come.

CHIMAMANDA NGOZI ADICHIE

If Chimamanda Ngozi Adichie is her writing career, she is insightful, successful, and award-winning. If she is her speeches, she is a feminist and storyteller, both inspiring and forward-thinking. If she is her physical presence, she is bright, to the point, and well-spoken. Chimamanda is a Nigerian who has lived in America, and an American college student who has lived in Nigeria. She is an observer—of racial injustice, of gender inequality, and of human nature. She is a novelist, an essayist, a feminist, and a mother.

Chimamanda was born in Nigeria in 1977. Her father was a college professor at the University of Nigeria and her mother worked at the school as registrar. Education was prioritized, and Chimamanda was an excellent student. She briefly studied medicine—the sciences were emphasized in Nigeria—before leaving for America, where she studied communications. All the while, she wrote. She wrote a small book of poetry at seventeen, wrote for journals and magazines in Nigeria and America, and was already writing her first novel, *Purple Hibiscus*, when she graduated from Eastern Connecticut State University summa cum laude.

Chimamanda received her master's in creative writing from Johns Hopkins in 2003. She went on to receive a master's in African studies from Yale, and then to receive fellowships from Harvard and Princeton. She was granted a MacArthur Fellowship, informally known as "The Genius Grant," in 2008.

In a Ted Talk, titled, *The Danger of a Single Story*, Adichie speaks of meeting her American college roommate. Her roommate's questions revealed that she had a single story of Africa—she expected Chimamanda to listen to tribal music, not Mariah Carey; she was surprised that Chimamanda spoke English so well, confused that English was the official language of Nigeria. How could an African nineteen-year-old possibly have anything in common with an American nineteen-year-old year old? Chimamanda also speaks of her own surprise as a young girl when she learned that her family's servant had a brother who made beautiful baskets. All Chimamanda knew of the servant was that he was poor, and that his family welcomed handouts and castoffs. That they possessed artistry was unthinkable. In her mind, they were poor—end of story.

Chimamanda's sense of this type of shortsightedness, how it colors our human experience, is never so clear as it is in her stories. Her characters are complicated and multidimensional, and their true natures are often hidden, even from themselves. But as a writer, Chimamanda has the power to ensure that the reader sees all sides of their stories.

After publishing *Half of a Yellow Son* (2006), *The Thing around Your Neck* (2009), and *Americanah* (2013), Chimamanda wrote essays on feminism. Each novel she has written has been more ambitious in scope than the last, taking on larger and more difficult aspects of the Nigerian experience. Perhaps more essays on feminism are in her future, or more novels and short stories, or more speeches. One thing is for certain: she has more stories to tell.

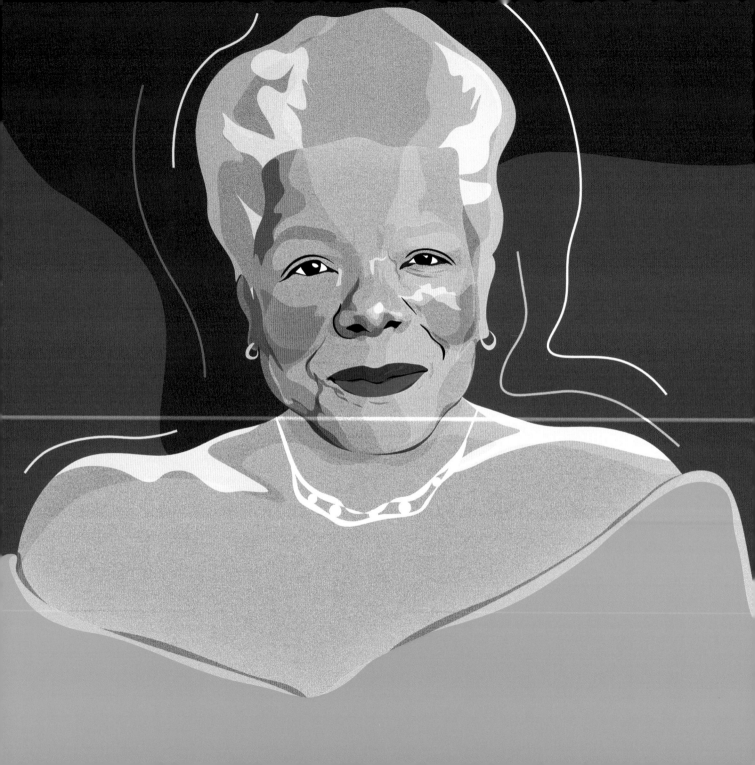

MAYA ANGELOU

Imagine a life so full, so varied that seven autobiographies don't do it justice. Maya Angelou was a poet, a civil rights activist, a dancer, a teacher, and an actress. When she was sixteen years old, she worked as the first black female cable car conductor in San Francisco. She wrote and directed films. She worked as a journalist. She was Martin Luther King, Jr.'s colleague when she worked for the Southern Christian Leadership Conference. She danced with Alvin Ailey in San Francisco and wrote alongside James Baldwin in Harlem. She performed the role of Kunte Kinte's grandmother in the acclaimed television show *Roots*, and was the White Queen in Jean Genet's off-Broadway production of *The Blacks*. She taught and lectured at Wake Forest University. She made Tupac Shakur cry.

Maya was born Marguerite Annie Johnson in St. Louis in 1928. The story goes that her beloved older brother, Bailey, called her Maya as a diminutive of "My Sister"—or "Mya Sister." Maya and Bailey were incredibly close throughout their lives, a connection likely forged because the siblings were sent back and forth between St. Louis and Stamps, Arkansas, as children. Maya chronicled her childhood in her first and most famous autobiography, *I Know Why the Caged Bird Sings*. Though she suffered sexual abuse and overt racism as a child, Maya had her brother and her grandmother and her great uncle, and she had literature and poetry, and she took the trauma she experienced and used it to hone a will so strong that activists will stand on her shoulders for generations to come.

Maya's contributions to American culture and literature are proof that out of the darkness comes light. Bill Clinton asked Maya to compose a poem for his first inauguration in 1993. When she read *On the Pulse of Morning* standing on the steps of the Capitol that January day, she was the second poet to recite her work at a presidential inauguration, following Robert Frost's recitation of *The Gift Outright* at President John F. Kennedy's inauguration in 1961.

Maya had a fierce intellect and she demanded respect, both for herself and for those around her. Legend has it that Maya would hush an entire party if she heard a disparaging word. In an interview, she spoke to the idea, saying, "You develop courage by doing the small things that take courage. Like not sitting in a room where racial pejoratives are used. Like not sitting in a room where gay people are being bashed." Maya Angelou, a giant of American activism, felt an imperative to take a small and personal stand against injustice, each and every time she encountered it.

There is a thread that runs through American culture from the 1950s to the present day, one that will not tarnish with the passing of years. Maya Angelou wove that thread deeply into the fabric of our lives, with her words and with her actions.

"We may encounter many defeats, but we must not be defeated."

RUTH ASAWA

Ruth Asawa's most famous works are beautifully woven sculptures made of wire. They define space without enclosing it, allowing light and air to pass through, like cages incapable of containment.

Ruth's parents were Japanese immigrants who worked as farmers in Southern California, and Ruth has memories of dragging her feet on the ground to make long looping lines in the dirt while riding on the back of farm equipment. She and her siblings worked alongside her parents on the farm, until they were sent to an internment camp for Japanese Americans during World War II. While her artistic talent was recognized early—Ruth won prizes for her art in grade school—it wasn't until she arrived at the camp that she met and took lessons from professional artists. She received a scholarship from a Quaker organization that supported Japanese American students, and decided to pursue a teaching degree. Though she completed all her coursework, she was denied a diploma based on her race. Her instructors felt the degree would be useless; no one would hire a Japanese American teacher.

So Ruth forged her own path. She enrolled at Black Mountain College in North Carolina. Ruth spent three years at the progressive school, where art was at the center of the curriculum and individualized education was a founding principal. The school proved instrumental in Ruth's development as an artist. "I spent three years there and encountered great teachers who gave me enough stimulation to last me for the rest of my life—

Josef Albers, painter, Buckminster Fuller, inventor, Max Dehn, the mathematician, and many others. Through them I came to understand the total commitment required if one must be an artist."

Ruth's work weaving with wire began after a trip to Mexico, where she encountered a man making egg baskets. Though Ruth tried to protect her hands, she frequently cut herself folding and bending the stiff wires. The loops and oblong hourglass figures of her sculptures evoked the shapes she had made, dragging her feet in the dirt behind tractors. Her creative process, like the menial labor she'd known as a child on the farm, involved hard work and slow, painstaking effort. But now her life's work lay in the act of creation rather than the seasonal output of the farm.

Ruth married fellow Black Mountain student and architect Albert Lanier. They moved to San Francisco and started a family, folding their children into their creative lives. Ruth was an active and passionate advocate for arts education, notably in San Francisco where she co-founded the Alvarado Arts Workshop and the San Francisco School of Arts. The latter was later renamed Ruth Asawa School of the Arts in her honor.

Ruth Asawa did not allow adversity to define her. She made art as a response to her life's experiences, and she dedicated herself to ensuring that others would have creativity in their own lives. She knew first hand, art can be a powerfully sustaining force.

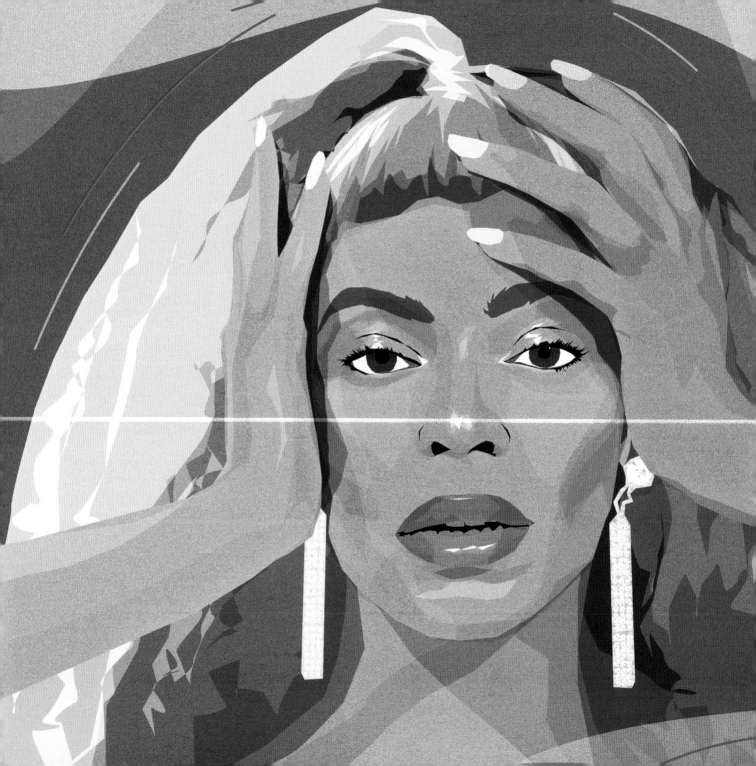

BEYONCÉ

Beyoncé Giselle Knowles was born in Houston in 1981. Her mother, Tina, owned a beauty salon, and her father, Matthew, worked in sales for Xerox. Beyoncé and her younger sister, Solange, both showed talent at a young age. Beyoncé began performing in Girls Tyme, a group that performed around Houston, and eventually landed a spot on *Star Search*. Girls Tyme went on to become Destiny's Child, and while the membership was fluid in the early days, the group was ultimately made up of Beyoncé, Kelly Rowland, and Michelle Williams.

Beyoncé was sixteen years old when Destiny's Child had their first big break—*Killing Time* was featured on 1997's international blockbuster, *Men in Black*. The group went on to great critical and commercial success, releasing five albums over the next nine years. The three women were working on solo projects in addition to performing as a group, and with the release of their final album, *Destiny Fulfilled*, in 2004 they closed a chapter on their collaboration.

Beyoncé's released her first solo album, *Dangerously in Love*, in 2003. She acted as executive producer and wrote many of the songs. Rapper Jay-Z was featured on a couple of the tracks, fueling speculation that the two were dating. Beyoncé had been featured in a song on Jay-Z's album the year before, and his presence on *Dangerously in Love* seemed like official confirmation that the two were in a relationship.

Beyoncé released *B'Day* in 2006 to coincide with her twenty-fifth birthday, and introduced her alter ego to the world with 2008's *I Am . . . Sasha Fierce*. Beyoncé and Jay-Z married in 2008, and Beyoncé gave birth to their daughter, Blu Ivy, in 2012, and twins, Rumi and Sir, in 2017. Perhaps it was marriage and motherhood that allowed her to become a more assured and outspoken artist, but she took control of her career in ways both inspiring and impressive. As her fame and influence grew, so has her intent to raise social awareness with her music and performances. *Lemonade*, her HBCU-themed show at Coachella, and the release of her documentary, *Homecoming*, were evidence that Beyoncé the artist-activist had arrived.

As Beyoncé has become outspoken in her art, she's become more elusive with the public. She'll occasionally pen an essay for a magazine in place of an interview, and her use of Instagram could serve as a case study for Social Media 101. But she guards her privacy fiercely. She has released films and documentaries alongside her albums, and has signed with Netflix to produce content for the streaming giant, but while personal and professional footage is featured in the films, Beyoncé is incredibly sparing with what she will show the world. It's an admirable feat in the era of selfies and oversharing—it would be impressive even if she weren't one of the most famous women in the world.

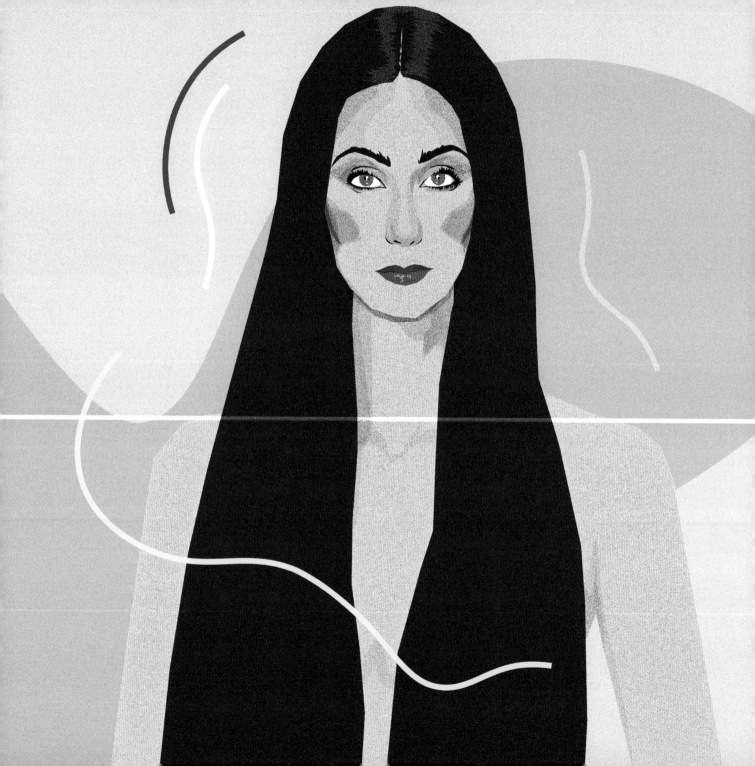

CHER

Cher is stubborn, and shy, and utterly glam. She speaks her mind, and tells corny jokes. She's vulnerable, she's powerful, and she wears outrageous outfits.

Cher was sixteen when she met Sonny Bono. Sonny got her a few backup singing jobs—she's singing behind the Righteous Brothers on "You've Lost that Loving Feeling," and the Ronettes on "Be My Baby"—but he wanted to launch her as a solo act. But Cher had stage fright, and she wanted Sonny onstage with her. "I've Got You, Babe" launched the two singers into the stratosphere when it debuted in 1965. They quickly became the "It" couple, and teenagers every-where emulated their groovy style. Furry vests and peasant shirts pushed out the early-sixties mod look; though when *The Sonny and Cher Comedy Hour* debuted in 1971, they showcased a decidedly more glamorous look.

Cher's decades-long collaboration with Bob Mackie produced her most iconic outfits. He designed her costumes for the show, and viewers tuned in as much for the songs and the jokes as they did to see what Cher would wear next. She attended the very first Met Ball in 1974 with Bob on her arm, wearing his "naked dress"—sheer and slippery with silver spangles, and cuffed and hemmed in white fur. Mackie said of Cher, "She's never intimidated by anything she wears."

Sonny and Cher had a child in 1969, and their television show ran from 1971 to 1974. They divorced the following year and Cher was briefly married to Gregg Almann. She had her second child with Gregg in 1976, though the marriage didn't last.

Singing her way through disco, country, and rock wasn't enough for Cher. Her breakthrough Hollywood role came in 1983, alongside Meryl Streep in Mike Nichols's *Silkwood*. She won Best Actress at the Cannes Film Festival in 1985 for her starring role in *Mask*, and received an Academy Award for her role in *Moonstruck* three years later. One year later in 1989, she was straddling a cannon on a war ship, surrounded by sailors, belting out, "If I could turn back time."

The constancy of her creative output took its toll on her health, and Cher decided to step back from her career in the early 1990s. When she came back, her twenty-second studio album, *Believe*, brought auto-tune into the mainstream, and gave Cher her biggest hit to date.

A Broadway biopic aptly titled *The Cher Show* opened in 2018, the same year Cher came full circle in her film career, appearing with her very first co-star, Meryl Streep, in the film *Mamma Mia, Here We Go Again*. That same year, Cher put out an album of Abba covers and embarked on another world tour.

Through films and songs, in Vegas residencies and Broadway shows and on world tours, Cher continues to reinvent herself. Her career choices seem quixotic, but Cher claims her decision-making process has been pretty easy. When something is presented to her, more often than not Cher will simply say, "This could be fun."

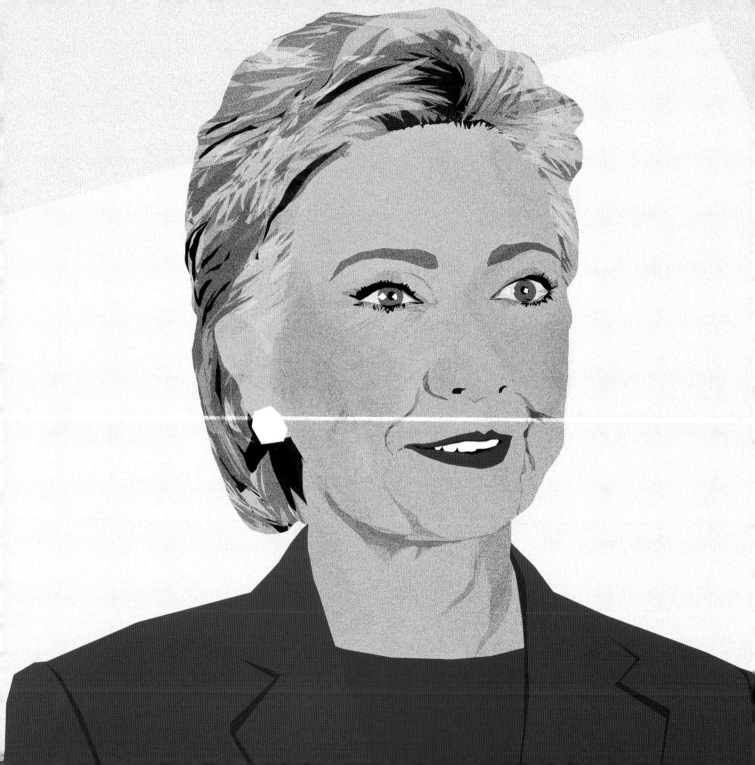

HILLARY CLINTON

Hillary Rodham Clinton is a woman of "firsts." She was the first woman to be nominated President of the United States by a major political party. She was the first First Lady of Arkansas to hold a job while her husband was governor. She was the first former First Lady of the United States to be elected to the US Senate, and the first former First Lady to hold a federal Cabinet position.

Hillary was born in Chicago in 1947 and raised in nearby Park Ridge. Her parents were devoutly Methodist, and she had a solidly middle-class childhood. Hillary was a Brownie and then a Girl Scout, and she graduated from high school a National Merit finalist. She had a political awakening while at Wellesley College, and by the time she reached Yale Law School, she'd left her father's republican politics behind and was a democrat in her own right.

Hillary graduated from Yale and worked briefly in Washington, D.C. before moving to Arkansas to be closer to then-boyfriend, Bill Clinton. The Clintons married in 1975, and Bill became governor of Arkansas in 1978. As First Lady of Arkansas, she continued her work as a lawyer and law professor, in addition serving on various boards and committees, and co-founding Arkansas Advocates for Children and Families.

Hillary's work for and on behalf of children and women would be a constant throughout her career. As First Lady of the United States, she chaired a task force on health-care reform that resulted in the formation of the Children's Health Insurance Program, which provides health care for more than eight million children. During her speech at the United Nations Fourth World Conference on Women, she announced, "Human rights are women's rights, and women's rights are human rights once and for all." Hillary was the point person on the Adoption and Safe Families Act of 1997, an important bill that refocused the adoption process in the US on the needs of children, and provided services to adoptive families.

When Hillary was a senator for New York in 2001, she was instrumental in securing federal aid for first responders in the aftermath of the 9/11 terrorist attacks. As Secretary of State under President Obama, she negotiated with China, Russia, and the EU to enforce sanctions against Iran, thereby ensuring they would come to the table to discuss nuclear disarmament. She negotiated a ceasefire in Gaza, she introduced the Lilly Ledbetter Fair Pay Act, and she created an ambassador at large for global women's issues.

Throughout her career—at Wellesley and Yale Law, as a lawyer, a First Lady, a Senator, and Secretary of State, and on the campaign trail—Hillary Clinton has brought the full force of her fierce intelligence to play on behalf of the underserved, underpaid, and overworked. She has worked for equality and justice by revolutionizing government processes, and has spent her career changing the game from within the system.

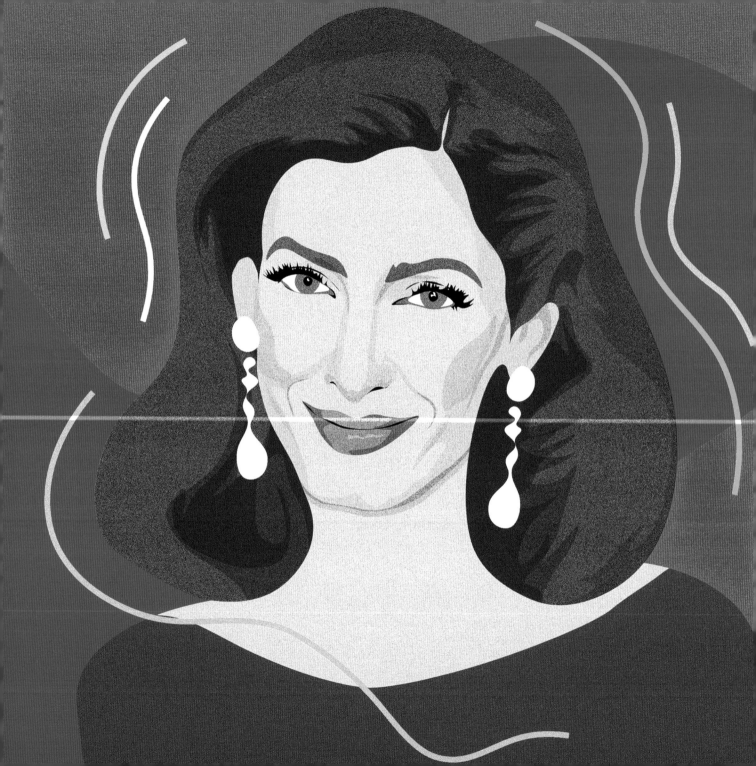

AMAL CLOONEY

She's a human rights lawyer who has tried cases at the International Court of Justice in The Hague. The United Kingdom appointed her the Foreign Office's Special Envoy on media freedom. She served as a senior advisor to Kofi Annan, and she counts prime ministers and Nobel laureates among her clients.

But just imagine how proud Amal Alamuddin's parents must have been when they heard who she was marrying.

In all seriousness, landing George Clooney might be up there with facing off against Vladimir Putin over Syria, on the difficulty scale. Amal would be the one to ask, as she's the only person in the world who has done both. Clooney had long and publicly claimed he'd never marry again, but less than a year after meeting Amal, he proposed to her. Amal said yes, and her private life suddenly became front-page news.

While her fashion sense had always been spectacular, now she was featured on magazine covers and blog posts. As Amal went on with her legal work—she has represented journalists who were incarcerated for reporting on genocide in Myanmar, and has spoken before the UN in an effort to establish a sexual violence resolution against ISIS—photographers followed her every move, and the tabloids reported exhaustively on *what she wore*. Throughout it all, Amal seemed unshaken by the fuss. She navigated the media frenzy with a quiet grace, while continuing her work in support of women's rights and freedom of speech.

Amal was born in Beirut in 1978, though the family moved to England a few years later to escape the Lebanese civil war. She attended school in Buckinghamshire, and went on to study at both Oxford and NYU. She's qualified to practice law in the United States and the United Kingdom, and she taught courses on human rights and human rights litigation at NYU and Columbia.

While Amal seems to be a reluctant celebrity, she has managed to find a bright side to the persistent scrutiny. In interviews she pivots from her personal life and instead uses her platform to raise awareness on human rights issues. In 2016, she and George established the Clooney Foundation for Justice, which "advocates for justice through accountability for human rights abuses around the world." She serves as president of the foundation, in addition to her work with the prestigious London law firm Doughty Street Chambers, and in 2017 she joined the ranks of working mothers everywhere when she and George welcomed their twins, Ella and Alexander.

It's obvious that to call Amal Clooney a celebrity would be to do her a grave injustice. Her life's work has been spent in defense of basic human rights, and time and again, she has refused to stand down in the face of the powerful and the unjust. Her name means "hope" in Arabic, but it seems her parents could have chosen from a number of names that would have suited her—justice, beauty, and intellect would serve equally well.

MISTY COPELAND

Misty Copeland became the first black principal dancer for the American Ballet Theater in 2015, when she performed the role of Stravinsky's Firebird. She was celebrated and feted for her history-making performance, but her journey had been difficult—she faced racism, and was told over and over that her athletic build and dark skin weren't suited to ballet. But Misty believed in herself. She worked hard, and refused to listen to her critics. In doing so, she made history.

When Misty was little, she loved to dance and would choreograph routines to Maria Carey songs for her sisters and friends to perform. She was the captain of her middle school's drill team when her coach suggested Misty try out the ballet class at the local Boys and Girls Club. At thirteen, Misty was a veritable old lady in ballet years.

Ballet is a form of dance that requires exhaustive practice and an intense focus on technique. Most dancers train for years to teach their bodies to hold the seemingly unnatural positions, and to jump and float in the air with lightness and grace. But when Misty was taught a new position, she could almost immediately hold it. She had an instinctual understanding of what was required of her body, and possessed the physicality and strength to perform well beyond her training. While she would certainly face discrimination in the predominantly white art form, one fact was undeniable: Misty was a prodigy.

Misty's mother moved often when Misty was young, and she and her siblings were uprooted frequently. Her childhood was far from stable, but ballet became Misty's respite from the chaos, and served as a grounding force in her life. When she was fifteen she won first place at the Music Center Spotlight Awards, and she attended the San Francisco Ballet's summer program on full scholarship later that year. She spent the next summer dancing in the ABT's summer program, and was offered a full-time position when the summer was over.

Misty delayed acceptance by a year in order to spend time with her family and to complete high school, joining ABT in 2001. Misty has said that she faced the first real racism of her career at ABT. While she'd never been allowed to forget the color of her skin, now the racism was out in the open. But it was also during this time that Misty began dancing with Dance Theater of Harlem. And she performed with the musician Prince, and befriended the pioneering dancer Raven Wilkinson. She found acceptance and understanding within her community, and within herself, and now that she has a platform, she's ready to share that sense of belonging with generations to come. "I'm going to continue to be who I am, and my experiences as a black woman have made me who I am. . . . Now that I am in this position, I'm not going to say 'I'm just a dancer.' It's a huge deal because I'm a black woman. That's why it's a big deal."

SOFIA COPPOLA

Sofia Coppola spent countless hours on movie sets as a child. She is Francis Ford Coppola's youngest child and only daughter, and when it comes to filmmaking, she likely absorbed as much of her father's genius as she inherited.

Sofia was thirty-nine years old when she became the first American woman to win the Venice Film Festival's highest honor, the Golden Lion. She won the award for her fourth film, *Somewhere*. By that point in her career, she had already had films nominated at the Cannes Film Festival and the Academy Awards. A few years after Venice, Sofia won Best Director at Cannes, for *The Beguiled*. She was only the second woman to do so in the festival's seventy-one-year history, and the first American woman.

While Sofia wasn't initially convinced she would follow in her father's footsteps—she tried her hand at fashion and modeling before making her first short film—the medium suits her. She writes her own films, in addition to directing and producing them, and she has a definitive sense of how they should look and feel. There is a line that runs from *Virgin Suicides* through *The Beguiled*, at once feminine and deeply contemplative, and she returns again and again to women: daughters and mothers, young wives and older spinsters, and almost always, teenage girls.

As a filmmaker, Sofia delves into the psychological underpinnings that drive her characters, and her costumes and settings often serve as characters, alongside the actors. *Marie Antoinette* can't be divorced of Versailles, just as the *Bling Ring* could only take place in fame-obsessed Los Angeles. The crazy clatter of Tokyo at night is that much more jarring when it butts up against the quiet elegance of the Park Hyatt hotel. Sofia establishes that sense of place in order to examine its effect on her characters, and her innate fashion sense means clothes and furnishings serve as eye candy as much as they create mood.

That Sofia has control over all aspects of her filmmaking is unusual. In addition to writing and directing her screenplays, she also acts as producer with financial backing from her family's production company. That level of creative control is in itself a luxury, especially for a young filmmaker, though few would have both the talent and restraint to use that privilege to create such quiet masterpieces.

Sofia is married to French musician Thomas Mars. They have two daughters, and divide their time between New York's West Village and Paris, where Mars' band, Phoenix, is based. In addition to her movies, Sofia has directed music videos as well as ads for the likes of Dior and Chanel. She was the face of Marc Jacobs' perfume, in ads shot by famed photographer Juergen Teller.

Sofia Coppola has established herself as a filmmaker in her own right, outside of the scope of her family and of her father's success. "Being underestimated is, in a way, a kind of advantage, because people are usually pleasantly surprised by the result." Unfortunately for Sofia, there is no longer a danger that she'll be underestimated.

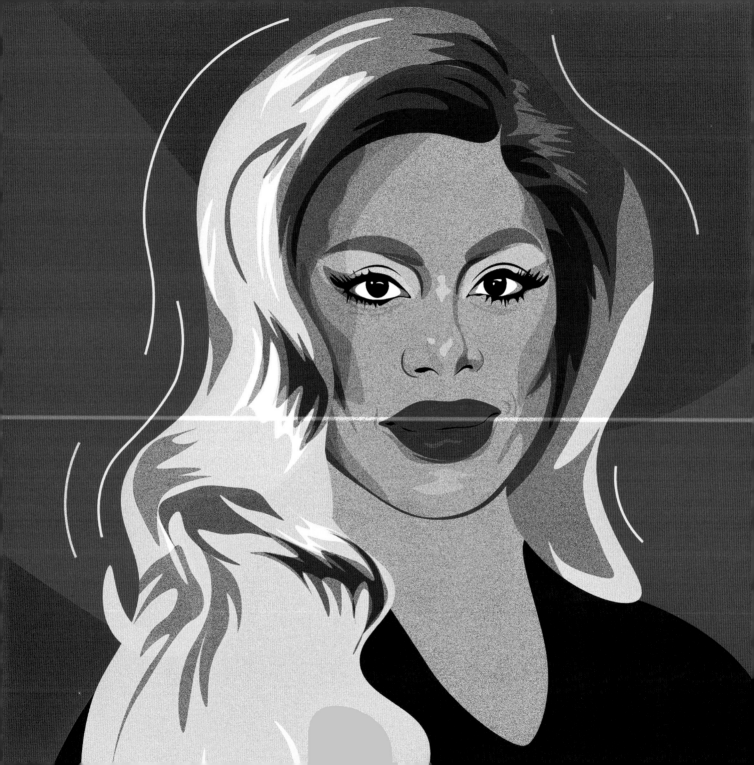

LAVERNE COX

Laverne Cox is an outspoken champion of transgender rights, and an advocate for the LGBTQ+ community. She's an award-winning actress and television producer who is committed to using her media exposure for positive change in our country and our culture.

Orange Is the New Black has been one of Netflix's most popular original series. In the show, Cox plays Sophia Burset, a transgender inmate at Litchfield Penitentiary. Her performance landed her an Emmy nomination—the first for an openly transgender person—and widespread fame soon followed. Cox had been working steadily for more than a decade, but when her profile rose to dizzying heights with her *OITNB* role, she gained a much broader audience for her message.

Cox produced a documentary on transgender youth in 2014 called *Laverne Cox Presents: The T Word*. The hour-long show follows seven young people as they navigate the world at different points before, during, and after transitioning. The documentary deals frankly with issues of violence against transgender people, the difficulties people face when their families and friends don't understand, and the tightrope walk of teen dating, which can be all the more precarious when you're transgender. Cox won an Emmy for the show, and was nominated for a GLAAD Media Award.

Laverne Cox has become a full-fledged trans activist, preaching compassion, acceptance, and self-love whenever she is given an audience. Simply by continuing to act and model in mainstream media outlets, Laverne would be breaking ground for the transgender community. But she not only takes the roles and the photo shoots (thank you, Beyoncé)— she also takes the interviews, and the magazine profiles. She corrects misconceptions on the spot, with eloquence and respect, as she did in an interview with Katie Couric; and she holds the media and their coverage of transgender issues to the highest standards. She's acknowledged the intensity of the pressure of being one of the "first," but she doesn't let it impede her progress.

While interviews and photo shoots and television shows and movies are all markers of success, and would be difficult to turn down because of it, the stakes are higher for Laverne. She is allowing herself widespread public exposure at a time when violence against transgender people, and specifically against transgender women of color, is disproportionately high. Her willingness to put herself in the spotlight is evidence of her bravery and her belief that this is a fight worth having.

Laverne Cox remembers a particular gift she received when she was a small child growing up in Alabama. Her mother gave her a history book on famous African American artists and leaders, and she loved reading it. "I thought how amazing would it be to have my work as an artist change the world in some way for people who may follow me."

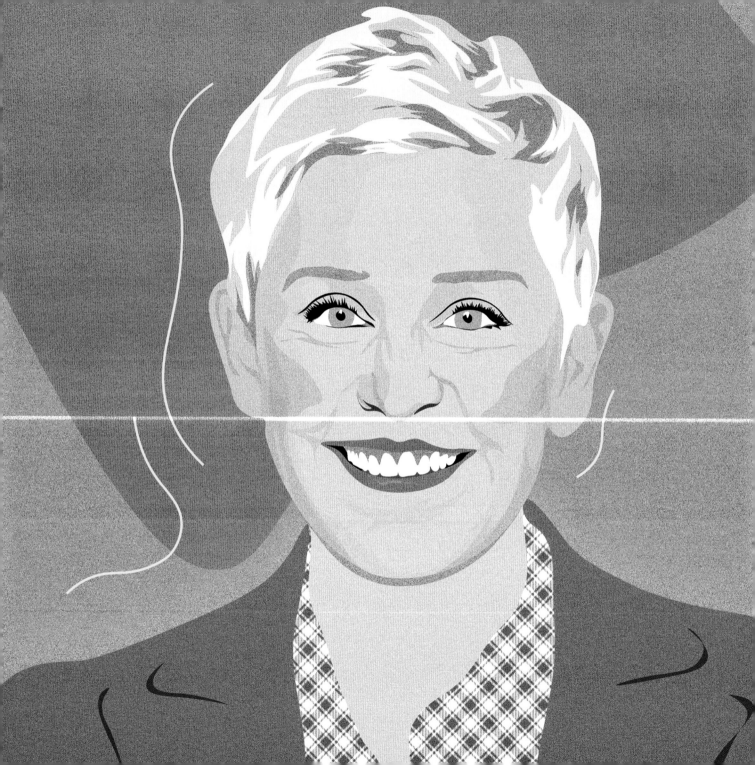

ELLEN DeGENERES

"Just keep swimming, just keep swimming." It's perfectly Ellen, in it's silly practicality, and it's a distillation of her genius (for humor, for personal connection, for being relatable) in its simplicity.

Ellen was the first and only female comic who Johnny Carson "called to the couch" when he was the host of *The Tonight Show*. It was 1986, and Ellen knew she was being anointed by the god of comedy, and that it was an honor he rarely bestowed. That appearance helped launch what would become one of the most successful comedy and entertainment careers in Hollywood.

But it hasn't been a steady climb. When Ellen came out, both publicly and as a character in her eponymous sitcom, the response was instantaneous. While she received support for her desire to live honestly, she was also met with public outrage, vitriol, and indignation. Think pieces were written about her and protests were mounted against the LGBT community. As for her career, it appeared to be the end of the line. Sponsors immediately dropped her show, and it was cancelled at the end of the season. Ellen was untouchable for the next few years, save for one project: she recorded the voice of Dory for Pixar's *Finding Nemo*.

Fast forward a few years to Ellen dancing her way through the opening segment of her daytime talk show, goofy and joyful and greeted with giddy delight by her studio audience. She has earned upwards of thirty Emmys for her show, and more People's Choice Awards than anyone in history. Ellen has hosted the Oscars, the Grammys, and the Emmys. She was named a CoverGirl, and she founded her own lifestyle brand, ED. It's all a reflection of how far America has come in the fight for equality and tolerance, of the respect and compassion that Ellen shows her audience and her guests, and of how much the majority of Americans just plain adore her.

Ellen's legacy is one of equality and justice, and not just for her fellow humans. She's an outspoken advocate for animals and animal welfare, and along with her wife, Portia, is a committed vegan. As part of a birthday gift from Portia, the Ellen DeGeneres Wildlife Fund was established to support Dian Fossey's anti-poaching foundation in Rwanda. Ellen has been PETA's Woman of the Year, was named Special Envoy for Global AIDS Awareness by Secretary of State Hillary Clinton, and was awarded the Presidential Medal of Freedom by President Barack Obama. As President Obama said, in a speech during the awards ceremony, "It's easy to forget now, just how much courage was required for Ellen to come out. On the most public of stages almost twenty years ago, just how important it was—not just to the LGBT community—but for all of us, to see somebody so full of kindness and light, remind us that we have more in common than we realize, and push our country in the direction of justice."

JOAN DIDION

Joan Didion. She of intense intellect, chic and rail thin usually with a cigarette in hand. Joan wrote to make sense of the world, she wrote in order to understand. In doing so, she helped readers to see the world as it changed around them.

Joan went to San Francisco's Haight-Ashbury district in 1967 to witness the counterculture firsthand, and she came back with *Slouching Towards Bethlehem*, a collection of essays that helped define the era. She wrote about California by way of Hollywood and Charles Manson, and about American politics by way of Dick Cheney and Bill Clinton. She also wrote, with uncharacteristic emotion, about the death of her husband and the nature of grief. And then about the death of her daughter, and the vagaries of motherhood. Even when she turned that unflinching reporter's eye inward, it still persisted in excavating, in making sense of the rubble.

Joan was born in Sacramento and attended the University of California at Berkeley. She was a *Vogue* reader and when the magazine's Prix de Paris writing contest was announced, Joan submitted an essay and won. She moved to New York in order to take the job that came with the prize, met the writer John Gregory Dunne, fell in love, and got married.

In *The Year of Magical Thinking*, written in the aftermath of John's sudden heart attack, Didion writes specifically about what happened—they'd lit a fire that night, John had a whiskey—and then with a small degree of distance of how she felt in the days and months afterward. She turns to poems she studied in graduate school, to Emily Post's entry on the etiquette of grief, to medical descriptions of what happens to the body during cardiac arrest. Joan was a writer who relied on research, and she read everything she could get her hands on in an attempt to make sense of what had befallen her.

John and Joan were both highly regarded writers, and they were each other's most trusted readers. The two had a successful collaborative career writing screenplays, which garnered them Hollywood money and a glamorous lifestyle. They raised their only child, Quintana Roo, amidst the parties and famous people, but at the end of the day, it was just their threesome—John, and Joan, and Quintana.

Of course, in the end it was just Joan and her words. She has said she wrote her first novel, *Run River*, after she'd moved to New York, and that the process of writing about Sacramento served as a soothing balm to her homesickness. And on the genesis of *Slouching Towards Bethlehem*, she wrote, "I went to San Francisco because I had not been able to work in some months, had been paralyzed by the conviction that writing was an irrelevant act, that the world as I had understood it no longer existed. If I was to work again at all, it would be necessary for me to come to terms with disorder." Again and again, Joan Didion turns to her typewriter. Again and again, her readers are the better for it.

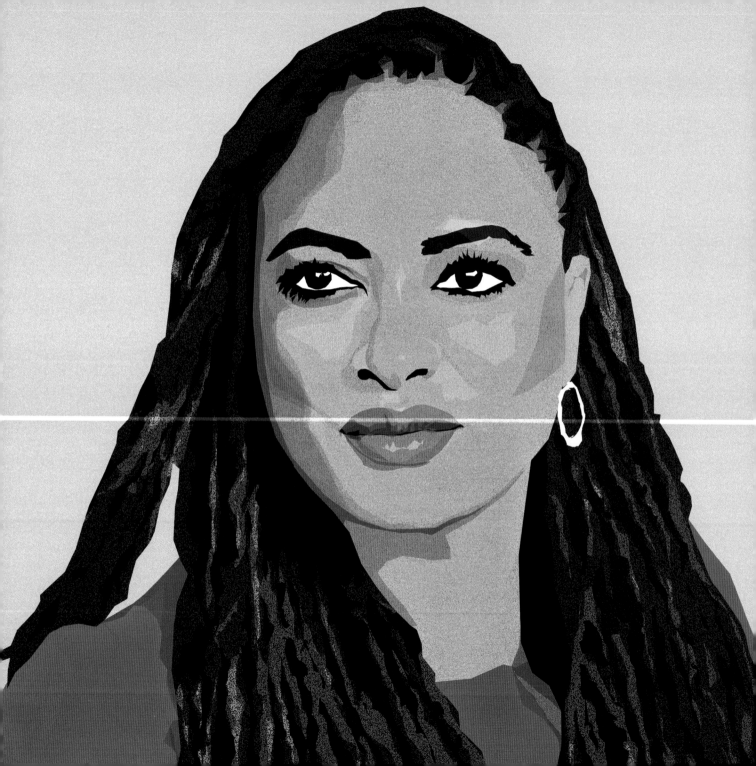

AVA DuVERNAY

Ava DuVernay makes award-winning movies, television shows, and documentaries. She's a writer, director, and producer, and a fierce advocate for women and people of color. Her talent and her critically acclaimed films have given her real agency in Hollywood, and she has become a principal player in the fight for inclusion and social change in the film industry.

Ava made her first-full length movie, *I Will Follow*, in 2010 using $50,000 of her own money. Eight years later, when Disney hired her to direct *A Wrinkle in Time*, she became the first black woman to helm a movie with a $100 million budget. It wasn't shocking that the studios were clamoring to work with her. Her second film, *Middle of Nowhere*, had garnered her a directing award at Sundance (she was the first black woman to receive the prize), and her third, *Selma*, received a best picture nod at the Oscars. Netflix was close on the studios' heels, offering Ava carte blanche to make any documentary she wished. The result was *13th*, a scathing look at racism and the prison-industrial complex, which went on to receive an Oscar nomination in the documentary category.

In 2013, Ava was only the second black female director invited to join the Academy of Motion Picture Arts and Sciences. She's an outspoken advocate for systemic change in Hollywood, to advance inclusion in the film industry. She helped to establish Evolve Entertainment, a public-private partnership with the city of Los Angeles aimed at giving young people who wouldn't traditionally have access to the film industry jobs and internships. Ava committed to hiring only female directors for the first two seasons of *Queen Sugar*, the television show she co-created and co-executive produces for Oprah Winfrey's network, OWN.

Ava founded AFFRM in 2010, which evolved and was renamed ARRAY in 2016. ARRAY is a collective of arts organizations that advances films made by women and people of color. By supporting and promoting filmmakers who would otherwise find it difficult to get their films distributed, Ava and her partners ensure manifold viewpoints reach movie audiences, whether it's on the big screen or through streaming services.

The ability to move seamlessly between genres and issues is one of Ava's hallmarks. Her four-part series with Netflix, *When You See Us*, tells the harrowing story of the five young black and latino teenagers who were wrongfully convicted of raping a white woman in New York's Central Park in 1989. Ava has said she made the series to inspire change. She functions simultaneously as activist and filmmaker, and remains intent on highlighting the injustices that plague American contemporary society.

Ava DuVernay is humble in her accomplishments and quick to share the spotlight with her collaborators. She uses her prodigious gift for language and visual storytelling to make the world a better informed, more just place. And she's mindful of her role as someone who has achieved so much success in Hollywood, as she made clear in a speech at South by Southwest, "When you win awards and the light is on you, I hate to tell you, it's not enough. If your dream only includes you, it's too small."

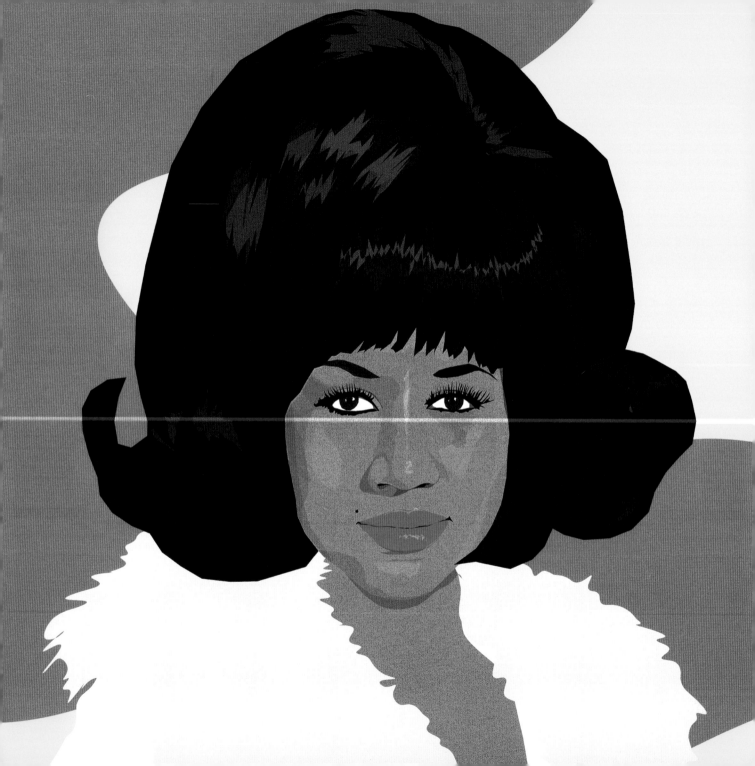

ARETHA FRANKLIN

When Otis Redding first heard Aretha Franklin's version of his song "Respect," he turned to his producer and said, "I just lost my song." Aretha didn't write all her songs but the way she sang them was a different form of creation, a different kind of ownership.

Gospel music permeated Aretha's childhood, and her father's empowering sermons on God's love and political activism were always with her. C.L. was a renown Baptist preacher, and her mother, Barbara, was a gospel singer and pianist. Aretha sang her first solo in C.L.'s church in Detroit when she was just ten years old, and when she was old enough, she joined C.L. on his gospel tours around the country. When she was eighteen, she asked permission to try to cross over to pop music, and her father, recognizing her talent, supported her.

Aretha's biggest hits were calls to action. While she claims not to have written them as such, she was proud when they became anthems. Aretha was surrounded by the luminaries of the civil rights movement in her youth, and the women's liberation movement coincided with her rise to fame. She reconstructed Otis Redding's song so that it was a woman, not a man, demanding respect. She and her sisters rearranged the song, spelling out R-E-S-P-E-C-T, and powering the beat forward with *sock it to me, sock it me, sock it to me*. These were women who were raised by C.L. Franklin; they knew how to preach.

Aretha's early records with Columbia stand the test of time, but producers hadn't quite figured out how to showcase her voice. As her father said when he introduced her on her bestselling gospel album, *Amazing Grace*, "Aretha can sing anything." It was Jerry Wexler at Atlantic who finally figured out to do with her instrument—he let Aretha sing what she wanted to sing. Together they recorded some of her best known songs—"Think," "Chain of Fools," "Do Right Woman, Do Right Man." The Queen of Soul was on her way.

In February 1968, MLK Jr. presented Aretha with the Drum Beat Award of the Southern Christian Leadership Conference, honoring her contributions to the civil rights movement. Just two months later, King was assassinated and Aretha sang "Take My Hand, Precious Lord" at his funeral.

Whether it was her faith, her close-knit family, or her music, Aretha was able to weather many storms in her life. When she died in 2018, she was remembered as much for her voice as for what she embodied. Aretha Franklin was the first woman inducted into the Rock and Roll Hall of Fame in 1987. President Obama said of Aretha and her music, "Nobody embodies more fully the connection between the African American spiritual, the blues, R and B, rock and roll—the way that hardship and sorrow were transformed into something full of beauty and vitality and hope."

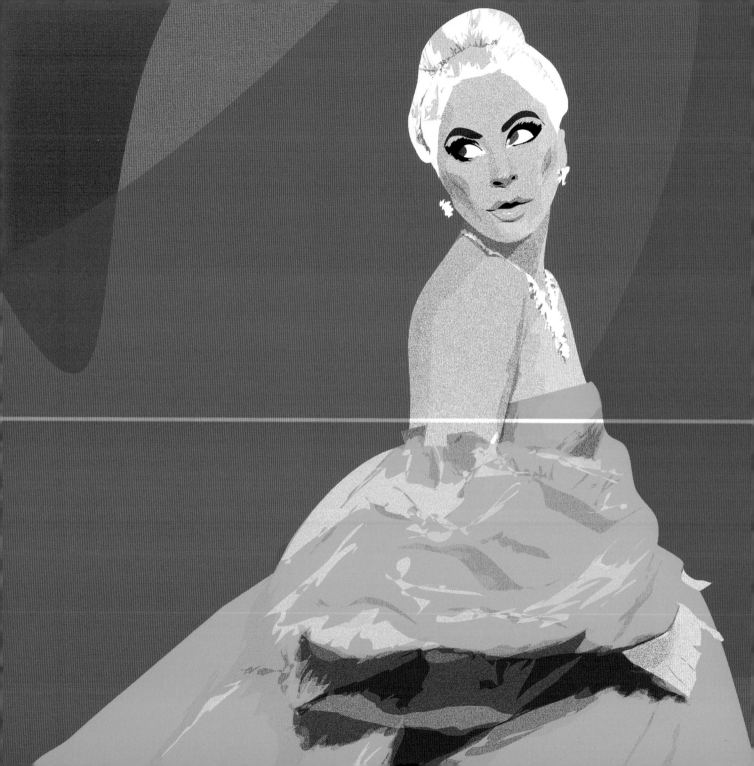

LADY GAGA

Lady Gaga was created, not born. Her creator, Stefani Joanne Angelina Germanotta, was born in 1986 in New York. Stefani was raised in a close-knit Italian American family on the Upper West Side. She attended an all-girls Catholic school, was a gifted and well-trained pianist, and performed in school plays and musicals. She got good grades, practiced piano, and took acting classes on Saturdays.

Though she claims she has always been just as dramatic as she is now, it's not quite the backstory that we would expect of Lady Gaga.

By the time she was in high school, there was evidence of what was to come. Gaga would sneak out at night to hear bands play. She performed her music at open mics. Two years into college at Tisch School for the Arts, she decided to drop out to pursue music. When she signed her first record deal, she and her collaborator, Lady Starlight, were already a fixture on New York's club scene. The two played Lollapalooza in 2007. Gaga released her first album a year later.

"The biggest surprise to me has been my relationship with my fans. They've changed my life."

Gaga's "Little Monsters" are legion, and they're fiercely devoted to Mother Monster. Gaga founded the Born This Way Foundation in 2012, in large part because her fans' experiences were so real to her. She speaks of being bullied in school, and feeling ostracized for being different. Born This Way's mission is to create a kinder and braver world, by empowering young people and supporting their mental wellness. Lady Gaga is a staunch supporter of the LGBTQ+ communities, and frequently talks about the bravery it takes to "be yourself."

Lady Gaga's persona grew, in some ways, from a desire to continue being true to herself as she rose to fame. She uses outré fashion and art both to signal her non-conformity, and as a form of protection from so much attention. Perhaps recognizing that her style was beginning to eclipse her talent, Gaga began taking projects that showcased her voice. She sang a tribute to *The Sound of Music* at the Academy Awards, and recorded a jazz album with Tony Bennett. Her fifth album, *Joanne*, was stripped down musically, allowing Gaga's voice and emotion to come through.

While she sang at the Super Bowl's halftime show in 2017, it wasn't until 2018's *A Star Is Born*, that Lady Gaga officially hit mainstream culture. She was nominated for an Oscar for her role as Ally, and won the Oscar for Best Song for "Shallow." In a little more than a decade she has moved from classical pianist to pop star, and from pop star to actress. Gaga is a constantly evolving performer, seemingly shedding a skin each time she reinvents herself. Self-definition seems to be the one thing her fans can count on.

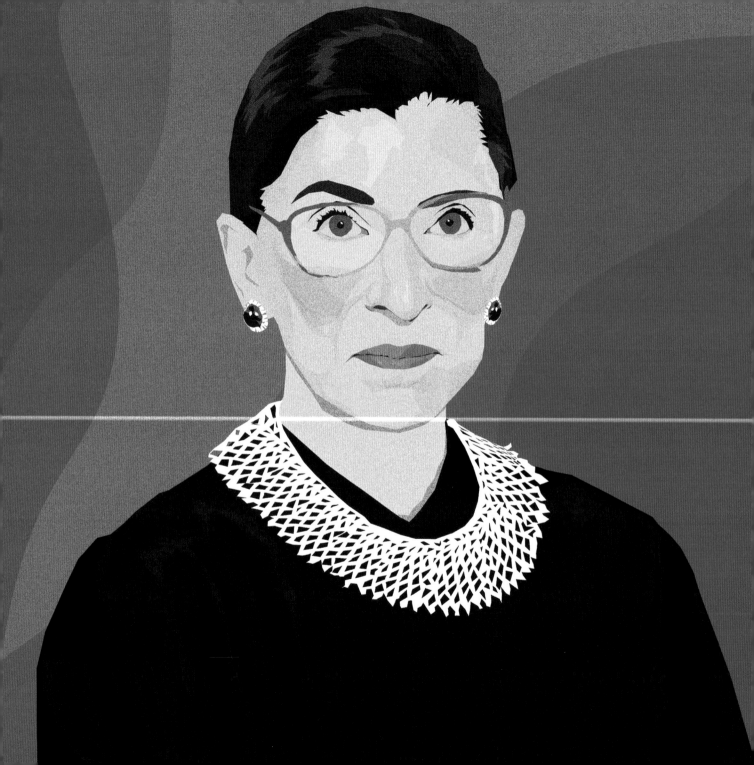

RUTH BADER GINSBURG

The Notorious RBG became a Supreme Court justice in 1993, but her impressive journey began decades before that. She entered Harvard Law School in 1956 when her first child, Jane, was fourteen months old. She was one of nine women in a class of more than 500 students. Her husband, Marty, had started a year before Ruth and when he was diagnosed with cancer during his third year, Ruth made certain he got copies of notes for each class, she typed his papers, and she took care of their young daughter. She was also on the Harvard Law Review that year, which most agree is a full-time job, in addition to taking her own classes. In characteristically understated fashion, Ruth has since said, "I grew confident in my ability to juggle that semester."

Hard work and academic prowess notwithstanding, Ruth had a difficult time finding a job upon graduation. She recognized that men were given an unfair advantage in many ways, and that the law didn't prevent those injustices. So she set out to rectify that injustice the best way she knew how—by changing the laws. She began taking gender equality cases, and of the six she argued before the United States Supreme Court, she won five. Ruth wrote a textbook on sex-based discrimination, created one of the first Women and the Law courses, and

helped formulate the Association of American Law School's non-discrimination policy with respect to women. She also co-founded the first American law journal devoted to gender-equality issues, and she founded the ACLU's Women's Rights Project. But women weren't the only ones to benefit from her tireless work. Ruth Bader Ginsburg fought against racism and income inequality, and on behalf of immigrants, gay people, and the disabled. She has long held that there should be an equal rights amendment to the constitution. If there ever is, it will be in large part due to the work she has done.

While she has garnered great fame and accolades in her eighth decade, she has quietly and consistently been doing this important work all along. When one of her Harvard Law Review peers was told that, when they were working together on the review, Ruth's husband had cancer, he was surprised at the news as she hadn't shown signs of strain. He remembered only that she "she set a standard higher than most of us could achieve." Ruth Bader Ginsburg has been there all along, working in systematic, case-by-case fashion to bring the American judicial system closer to the ideals set forth in the US Constitution, where all are equal, and the right to life, liberty, and the pursuit of happiness cannot be questioned.

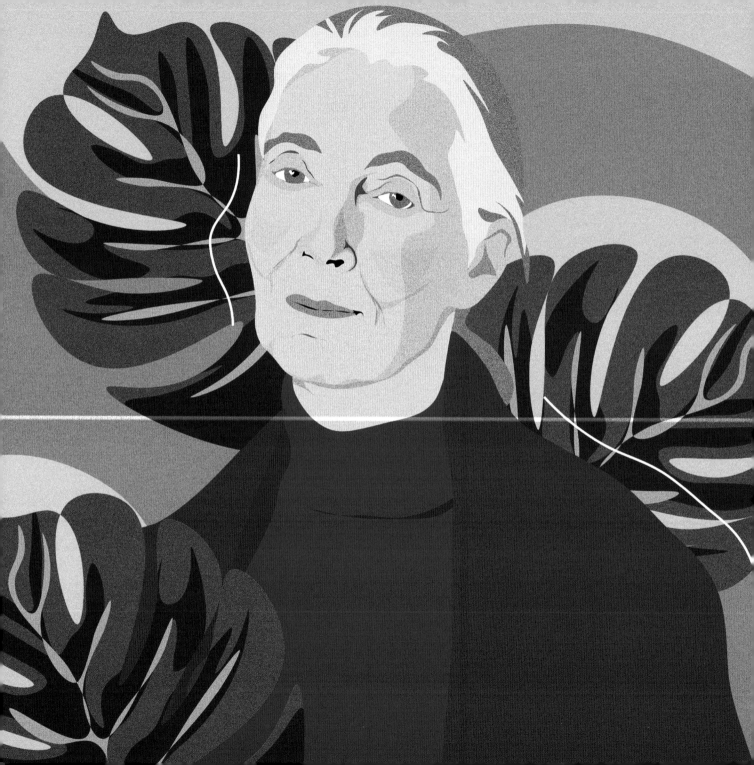

JANE GOODALL

Jane Goodall was just twenty-six years old and not formally trained in research when she witnessed one of the most important scientific breakthroughs of our age. As she watched quietly from a short distance away, the chimpanzee she'd named David Greybeard used a thick piece of grass to fish termites out of the ground. Jane was at Gombe in Western Tanzania, observing chimpanzees as part of a study organized by the archaeologist and paleontologist Louis Leakey, whom she'd met a few years before on her first trip to Africa. When she wrote to let Louis know what she'd observed, Leakey— exceedingly aware of the scientific significance of a chimpanzee using a tool—replied, "Now we must redefine 'tool,' redefine 'man,' or accept chimpanzees as humans."

Jane was born in Bournemouth, England, and spent her childhood among chickens, horses, and dogs. Her propensity to sit quietly and observe started at a young age. Jane tells a story of herself at five, when she disappeared for an entire afternoon. Her mother was sick with worry, and a search party had been mounted when Jane appeared walking across the field from the hen house. She'd been gone for close to five hours, and when she was asked where she'd been she replied, "With a hen." Five-year-old Jane had wanted to see how a hen laid an egg, so she sat—quiet and still—in a dusty, prickly henhouse, and waited patiently.

Twenty years later those same powers of observation were in full effect. Jane observed the chimps at Gombe long enough to learn that, contrary to what many researchers believed, chimpanzees ate meat, and that like humans, the chimps had personalities and emotions. National Geographic published a cover story on Jane's work in 1963, but when she reported her findings she was mocked for not being a "real" researcher, for giving the animals names instead of numbers. Jane pursued a doctorate in ethology at Cambridge, and when she graduated in 1965, she co-founded the Gombe Stream Research Center.

Over the next decade, in addition to her research at Gombe, Jane wrote a book, founded the Jane Goodall Institute, and was the subject of a documentary. In 1986, after learning how serious the threat of chimpanzee extinction was, Jane left research and became an activist. "I couldn't just stay in Gombe watching chimpanzees, leading an idyllic life. I had to try and do whatever I could." Jane went on to found Roots & Shoots, a youth leadership and empowerment organization; to establish animal sanctuaries in different parts of the world; and to organize community conservation work in Africa.

Jane Goodall is forever linked to the chimpanzees that live in the forest along the eastern edge of Lake Tanganyika, though for someone with such a grounded interest, she spends a surprising amount of time up in the air. Jane Goodall was named a UN Messenger of Peace in 2004, and she spends her time crisscrossing the globe, spreading the message of conservation.

ZAHA HADID

Zaha Hadid was a fierce and fearless innovator in the field of architecture. She designed with ambition and imagination, and her work continues to influence generations of architects and designers. When she died in 2016 at age sixty-five, the architecture world lost not only its foremost female architect, but also an uncompromising visionary.

When Zaha was growing up in Baghdad in the 1950s, the city was in a period of progressive and liberal development, and renowned architects like Le Corbusier and Frank Lloyd Wright were commissioned to design buildings. Zaha said her early interest in architecture was in part influenced by the plans—both built and unbuilt—for a reimagined modern Baghdad. Zaha was educated by nuns she has since called "eccentric" for their liberal approach, in a Catholic school in Baghdad that accepted Muslims and Jews. She went on to study mathematics at the American University in Beirut before she enrolled at the Architectural Association (AA) in London. It was there that she began her formal architectural training, and where she was exposed to vanguards in the field, like Rem Koolhaas, Elia Zenghelis, and Alvin Boyarsky.

Her mentors at AA emphasized the importance of drawing, design, and theoretical innovation, and Zaha was recognized early on for her ability to conceive of an entirely new kind of architecture in her paintings and models. She submitted the winning design in the Peak Leisure Club's architectural competition in Hong Kong in the early 1980s—and though the design was never realized, the recognition served to officially launch her career. She created drawings and models at a furious pace throughout the 1980s, continuing to push boundaries and innovate with form and structure.

With nearly a decade of research and drawing under her belt, Zaha began receiving commissions. Her first building, a fire station on the campus of the Vitra furniture company in Germany, was erected in the early 1990s. With the Rosenthal Center for Contemporary Art in Cincinnati, Zaha became the first woman to design a museum in the United States. Her designs had been derided as "unbuildable" for years. Yet with advances in both computer technology and engineering, Zaha's revolutionary designs became realities. Her firm grew to employ 400 staff members, with projects in more than forty countries. In addition to her private commissions, Zaha taught and held professorships at prestigious universities around the world.

Zaha was the first woman to win architecture's most prestigious award, the Pritzker Prize, and the first to win Britain's Royal Gold Medal in her own right, from the Royal Institute of British Architects. She was as exacting and uncompromising in her life as she was in her designs, and she eschewed labels, ever disdainful of those who referred to her as a "female architect" or an "Iraqi architect." Though when Rem Koolhaas described her as "a planet in her own orbit" at her graduation from AA in 1977, perhaps it was a fitting descriptor for a woman so intent on designing for an entirely new world.

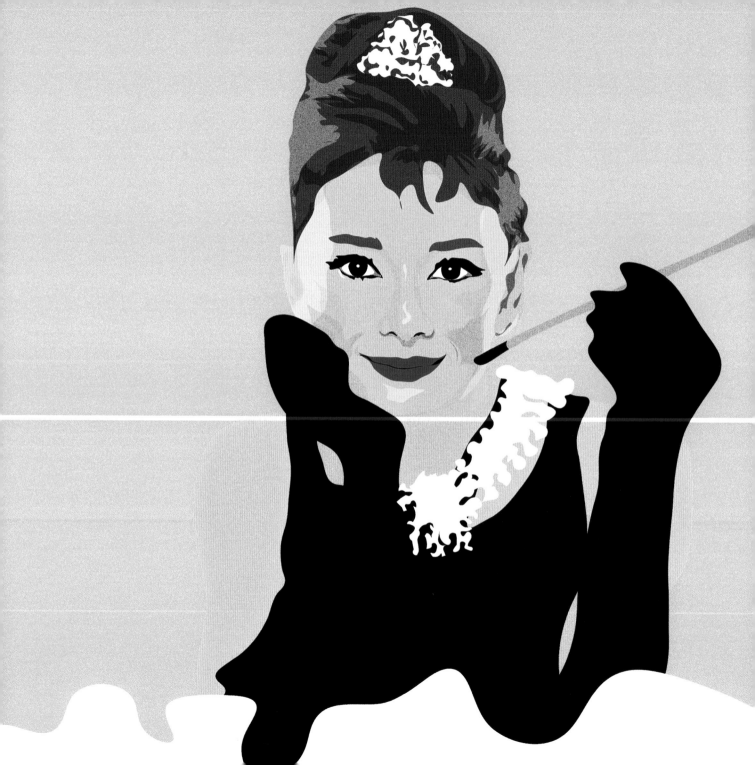

AUDREY HEPBURN

Maybe it's ballet flats paired with cigarette pants and a slim turtleneck. Or perhaps an ivory cigarette holder and pearls beneath a streaked beehive. Maybe she's a bit younger— a crisp short-sleeved blouse tucked into a flared midi skirt, dark hair tucked daintily behind elfin ears. Even without the wardrobe, Audrey Hepburn's look was nothing short of iconic. She had the sparkling eyes, the full eyebrows, and the perfectly painted lips of a true screen goddess.

Audrey Hepburn's mother was a Dutch noblewoman and her father was a British subject born in Austria-Hungary. The couple married in the Dutch East Indies, then moved to London before finally landing in Brussels, where Audrey was born. Her early childhood was a worldly and privileged one, though the idyll was soon broken—first when her father abandoned the family and soon after with the advent of World War II. Audrey's mother moved the family to Arnhem, thinking the Netherlands would be as safe as they had been during the First World War. She was wrong, and Audrey's family suffered greatly during the German occupation. She and her relatives were all active in the Dutch resistance, though the famine of 1944 took a serious toll on Audrey's health.

After the war Audrey pursued a ballet career, but when she was told she would never be a prima ballerina, she turned to acting instead. When the author Colette saw her filming a movie in Monaco, she insisted Audrey be the one to play the lead role in her new play, *Gigi*, on Broadway. Audrey received good reviews, but nothing prepared audiences and critics for her starring turn in *Roman Holiday*, opposite Gregory Peck. That year Audrey won a BAFTA, an Academy Award, and a Golden Globe, for her role as a princess who escapes her keepers for a wild night loose in Italy's capital. Her film career took off from there with starring turns in *Sabrina*, *Funny Face*, *Breakfast at Tiffany's*, and *My Fair Lady*. Her costumes were as famous as her roles, thanks in large part to her ongoing and close relationship with Hubert de Givenchy, who dressed her for most of her life. Audrey continued acting through the early 1960s, and though she occasionally took roles in her later years, she decided to step back from acting at the end of the decade, to take more time for her family.

Perhaps Audrey Hepburn's most important role was the one she took on later in life: UNICEF Goodwill Ambassador. She visited refugee camps in war-torn regions, raising awareness of the plights of those suffering, and spoke before Congress in an effort to secure humanitarian aid. It was a cause close to her heart; her own years spent in occupied Arnhem were ample reason to do what she could to help others in similar circumstances. Audrey Hepburn received the US Presidential Medal of Freedom in 1992 for her work with UNICEF. She famously said, "The 'Third World' is a term I don't like very much, because we're all one world."

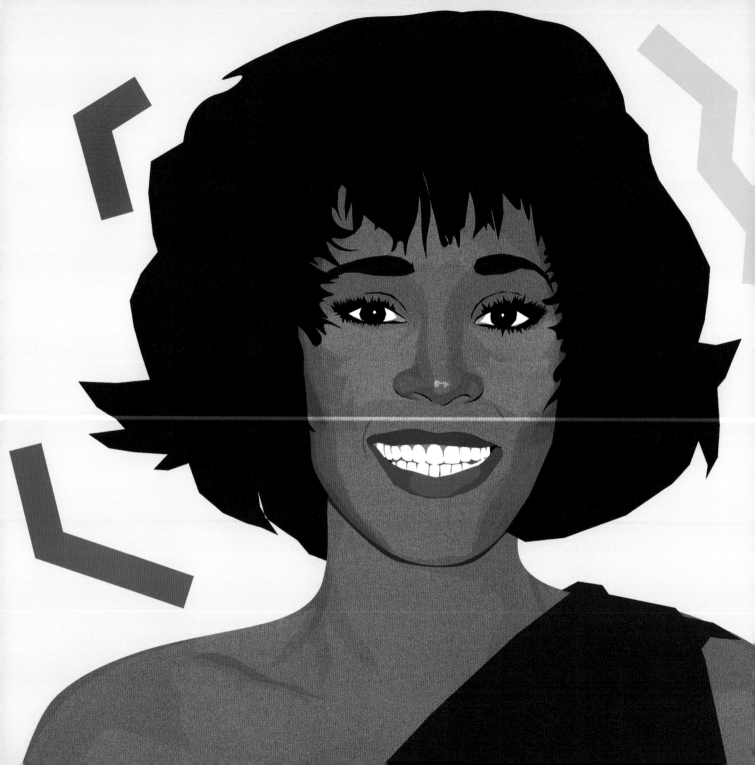

WHITNEY HOUSTON

Whitney Houston said of her godmother, Aretha Franklin, "She closed her eyes, and that riveting thing just came out. . . . That's what I wanted." It's hard to think of a more riveting, eyes-closed kind of song than Whitney's rendition of "I Will Always Love You" from her film debut, *The Bodyguard*.

Whitney was rooted in the gospel tradition, just like her mother, Cissy, her cousin, Dionne Warwick, and of course her godmother, the Queen of Soul herself. Cissy Houston led the choir at their church, and Whitney sang her first solo when she was eleven years old. Cissy was protective of her daughter—protective of her as a person, and protective of the immense talent that she possessed. Though Whitney's voice was awesome in the truest sense of the word, it wasn't until she'd graduated from high school that Cissy allowed her to sign her first recording contract. Clive Davis signed Whitney to Arista Records when she was just nineteen. He recognized the immensity of her talent, and he was careful and intentional with her career from the start. The relationship between the two proved to be one of the most enduring of Whitney's life.

Whitney's debut album, *Whitney Houston*, was near perfection. The songs speak for themselves, each catchier and more memorable than the last. "When Saving All My Love," "How Will I Know," and "Greatest Love of All" all went to number one in the charts, it was the first trifecta for a female vocalist on a single album. Houston's 1987 follow-up, *Whitney*, debuted at number one. "I Wanna Dance With Somebody,"

"Didn't We Almost Have it All," "So Emotional" . . . with just two albums, in the span of two years, Whitney was a star.

Whitney's mother had instilled her with a sense of social justice, and she used her great success to raise awareness for the causes closest to her heart. Whitney performed in honor of Nelson Mandela, the United Negro College Fund, and the Children's Defense Fund. She performed for those serving in the military, and when she performed a one-for-the-ages rendition of "The Star-Spangled Banner" at 1991's Super Bowl, she donated all the earnings of the recording to the American Red Cross.

In 1992, Whitney starred opposite Kevin Costner in *The Bodyguard*. She married R and B singer Bobby Brown that same year, and gave birth to their daughter, Bobbi Kristina, in 1993. Her acting and soundtrack album career flourished in the 1990s with *Waiting to Exhale* and *The Preacher's Wife*. She came back to studio albums in the late nineties and continued making music until she died, but as early as 2000 her personal struggles with drugs and alcohol, as well as her troubled marriage were making headlines.

Though Whitney Houston's image was tarnished at the end, nothing can overshadow her talent. As Clive Davis said, " . . . you realize why genius can be applied to only a few interpretive performers. She finds meaning and depth and soulfulness in a song that often the writer and composer never really knew was there."

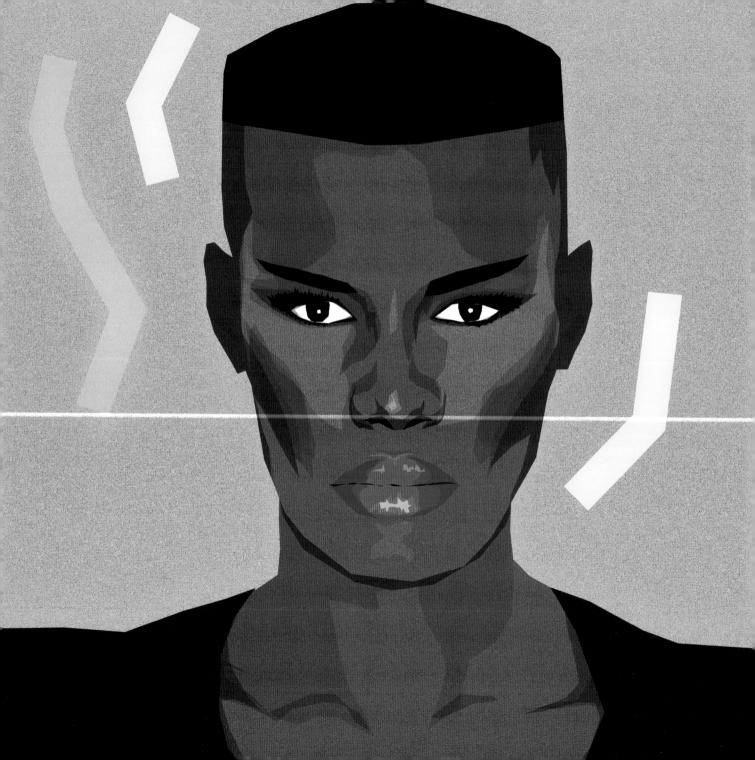

GRACE JONES

Grace Jones is a provocative performer, one whose only consistency is to consistently invert her audience's expectations. She engages using utter stillness or frenzied dance. She connects through the deep register of her voice or a swirling cascade of howls. She seems intent on the outrageous, most herself when she is a distortion of herself. She has worked with artistic visionaries throughout her career, collaborating with people who, like her, are interested in addressing notions of race, beauty, and gender head on—unless they're subverting them entirely. Grace Jones is a contrarian in the first degree. She titled her memoir *I'll Never Write My Memoirs*.

Grace was born and raised in Jamaica, as much a product of Spanish Town and the Pentecostal preachers in her family as she was the singers and performers of the West Indies. Grace moved to New York just on the cusp of her teenage years, and the culture she was exposed to in America helped her redefine herself. She moved to Paris in the early 1970s to pursue a modeling career, and when she was told she wouldn't be able to find work because she was black, she and a few others founded their own modeling company. She worked as a model, a singer, and an actress, and at the peak of her fame in the 1980s Grace Jones was ever-present, working with Keith Haring and Robert Mapplethorpe; singing at Studio 54; and wearing only the most au courant designers. Hollywood came calling; Grace was utterly unique in her ability to be both hypersexualized and androgynous. She could contort her features with the theatricality of a Kabuki master. She was both ruthless and seductive as May Day, in the James Bond film *A View to a Kill*. As Zula in *Conan the Destroyer* she battled for her life, fighting off a crowd of men intent on killing her so ferociously they back away, cowed by her fury. Though no single performance or creation defines her, 1982's *A One Man Show* comes close.

Grace Jones has been copied and emulated almost from the start. But to Grace, her mimics are missing the point. She didn't set out to be anything but herself, and she was and remains active in creating that image. "Whatever people think of me, I want them to keep thinking of me. I don't even mind if people make up things about me as long as they don't make me look boring or ordinary—as long as they don't smooth me out or reduce me." Through it all, it seems, Grace was simply intent on being known as one thing: herself.

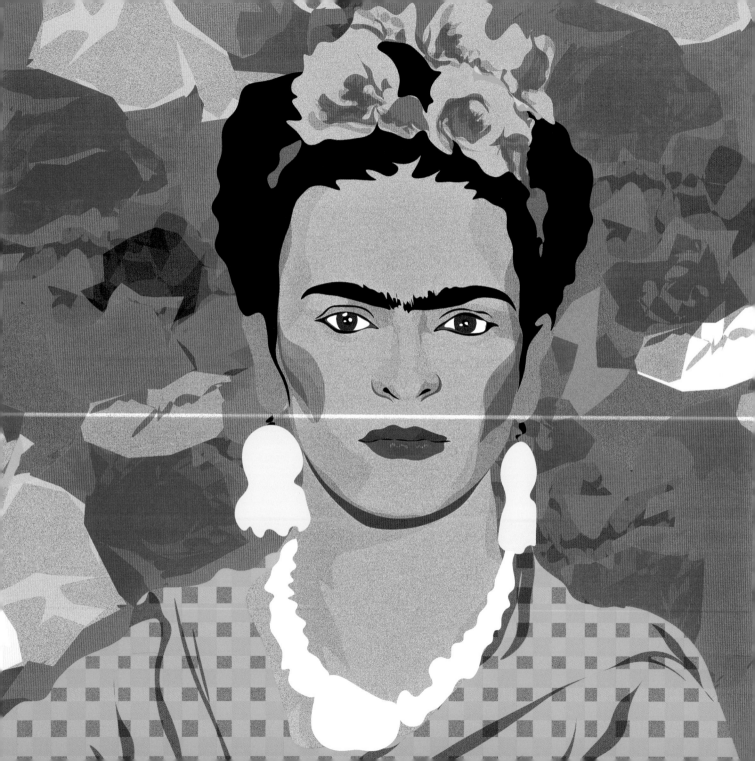

FRIDA KAHLO

Her affairs, her politics, her marriage, her ego—Frida Kahlo the artist has eclipsed the art she created. Her life story has achieved mythic status, littered as it is with tragedy, fame, and brushes with the great figures of her day.

Frida was six years old when she contracted polio. She spent months alone her in bed, and when she recovered and finally enrolled in school, she was older than the other students and suffered from a limp. Though she had trouble socially, she was an excellent student. She set her sights on a career in medicine, and stood out in high school for her political engagement and her outspoken nature. Everything changed when Frida was eighteen. She was riding a bus that collided with a street trolley and was impaled by a steel bar. Parts of her spine, pelvis, lower torso, and legs were broken, leaving Frida bedridden and alone for a second time in her young life. Her hopes for a career in medicine were dashed.

Frida turned to art for some solace during her long recovery. Her parents created a makeshift easel that functioned while she lay in bed. She came out of her convalescence with some assurance as an artist, and as politically engaged as ever. She joined the Mexican Communist Party in 1927, and married painter and fellow party member Diego Rivera in 1928. The two would divorce and reconcile over the course of their tumultuous relationship, and though both pursued extramarital affairs, they remained connected throughout their lives.

Surrealist André Breton was an early champion of Frida's work, and he secured her a solo show at a gallery in New York in 1938. The show was a success, and Frida's traditional Mexican style of dress caused a stir. She was feted as an artist and a fashion icon in New York, and when a second show was held in Paris the next year, the Louvre bought her painting *The Frame*, making her the first Mexican artist to be included in the museum's collection. Shows and exhibitions followed throughout the early 1940s, and as her star rose, so did her profile.

Frida's health continued to suffer though, and she underwent various surgeries in hopes of returning her body to wholeness, most of them only increasing her pain. When her first solo show was held in Mexico in 1953, many thought she would be too ill to come. Frida surprised them all by having her giant four-poster bed moved to the center of the gallery. She arrived in an ambulance, and was carried in on a stretcher to enjoy the show from her majestic perch in the center of the room.

Frida used her body as a recurring motif in her art, one that yielded to its master's every whim on canvas in a way it couldn't in life, the brokenness undergoing an almost holy transformation beneath her brush. The accident that should have killed Frida at eighteen instead propelled her career as a world-renowned artist of the first degree.

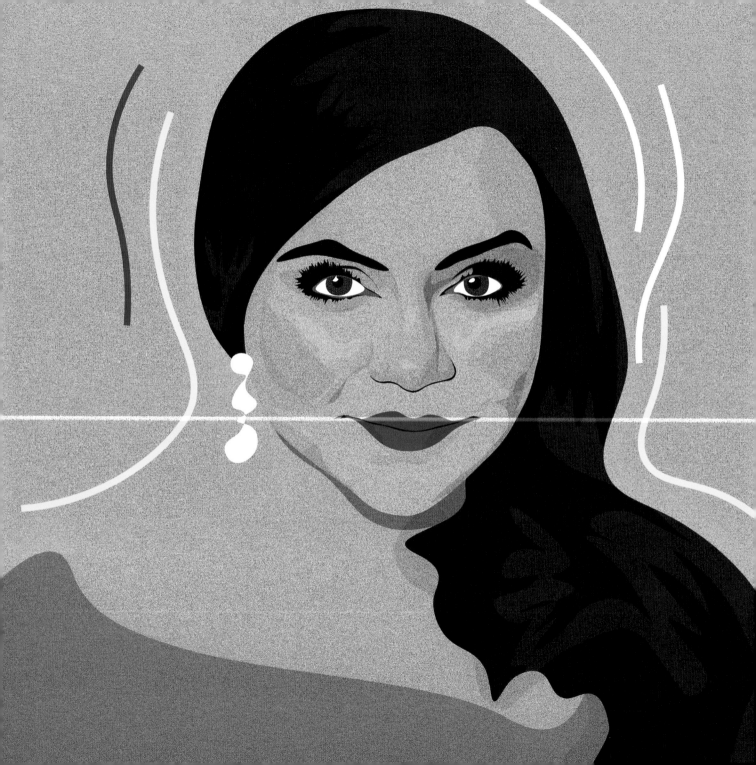

MINDY KALING

Mindy Kaling was twenty-four years old when she started writing for *The Office*. She was the only woman and the only person of color in the writer's room. Nine seasons later, she'd written twenty-four episodes (more than any other writer on the series), had been nominated for an Emmy Award for Outstanding Writing in a Comedy Series, and had created and was starring in a show of her own, *The Mindy Project*.

Mindy would be the first to point out that her success wasn't happenstance. She's a preternaturally hilarious writer who happens to take her work very seriously, and she has put in long hours in support of her career. Mindy was born in Cambridge, Massachusetts, shortly after her parents emigrated to the United States. Her mom was an ob-gyn and her dad was an architect, and though both were born in India, they met while working in Nigeria. Her parents worked hard throughout her childhood, and Mindy learned to do the same. She was a conscientious student who got good grades in school, though it turns out she wasn't only studying Latin.

"I could tell you who the line producer on 'Saturday Night Live' was when I was twelve years old." Mindy cut her comedic teeth on Comedy Central, watching the Church Lady and the Kids in the Hall. She joined an improv group in college, and was doing stand-up in Brooklyn after graduation. She got her big break when she and a good friend wrote and staged a play about *Good Will Hunting*-era Matt Damon and Ben Affleck. Two months after seeing the play in New York, *The Office*'s show runner, Greg Daniels, hired her to write for the show.

In addition to writing for *The Office*, Mindy went on to act, direct, and serve as an executive producer. She worked long hours, often arriving at six in the morning and not leaving until ten at night, and forged strong relationships, including with B.J. Novak, who is godfather to her daughter, Katherine. Motherhood seems to have shifted Mindy's priorities without dampening her drive, and she is very quick to point out that "doing it all" works for her only because she also has so much hired help, which isn't a fact many celebrities are willing to share.

In addition to her work on *The Office* and *The Mindy Project*, Mindy has written two collections of essays, as well as a feature film, *Late Night*, in which she co-stars with Emma Thompson. She's cognizant that she's an anomaly in more ways than one—a woman who is a successful comedy writer, a person of color who is creating mainstream entertainment content—and she's mindful of her legacy. "When I'm gone and people look at my body of work, they can see it in the context of where I came from and where my family came from and say, 'Wow, that was the beginning of a ripple effect.'"

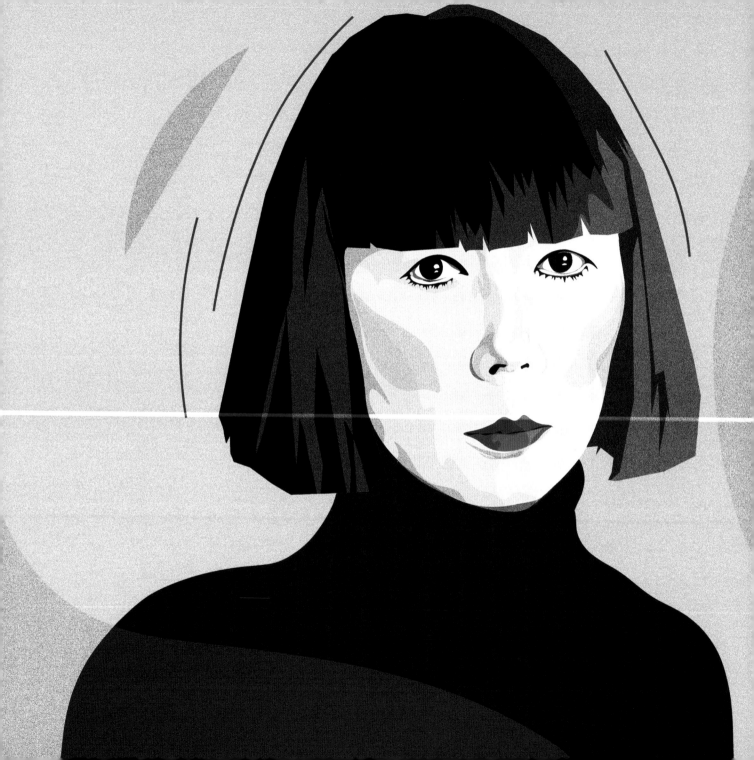

REI KAWAKUBO

Rei Kawakubo is fashion's vanguard. The Japanese designer began making clothes in the late 1960s, after working in a textile factory. She officially launched Comme des Garçons ("like some boys") in Japan in 1973. She'd built a loyal following by the time of her first Paris show in 1981—"the crows" flocked from Japan to the City of Light to see Comme des Garçons on the runway. At a time when designers were selling glossy glamour and attraction, Kawakubo's clothes were a revelation.

Kawakubo is in the business of creation. Her relationship to the fashion world is a complicated one—she claims to not know what her influences are; she is intent only on progress as it manifests through creating something new. She creates pieces of clothing (call them fashion, or art, or functional objects) that can't be divorced from the human form. "Clothes are only completed when somebody wears them."

Comme des Garçons has many fashion lines, including Comme des Garçons Homme, Comme des Garçons Noir, and Comme des Garçons Play. Kawakubo has elevated designers working for the company to their own posts, giving each designer a line (or lines) of their own, with complete creative freedom. Rei and her husband, Adrian Joffe, opened Dover Street Market in London in 2004, selling Comme des Garçons alongside other designers whose ethos fit their own. Joffee has said that prerequisites for inclusion in the market—which has subsequently opened locations in New York, Singapore, Beijing, Tokyo, and Los Angeles—are simply to be "independent artists with outsider spirit. Designers with something to say."

Kawakubo is a collaborative artist. Famed choreographer Merce Cunningham drew inspiration from the monumental spring/summer 1997 show, "Body Meets Dress, Dress Meets Body." The collection, affectionately known as "Lumps and Bumps" featured clothes worn over padded slips; but instead of shoulder pads to broaden shoulders or cups to create cleavage, the down inserts molded the model's backs into humps, or protruded from one hip like a bustle slipped sideways. Cunningham was taken with the collection and together the two artists produced "Scenario," a dance performance with costumes by Kawakubo and movement by Cunningham. The dancer's movements were punctuated by the bulges that shaped their bodies, bulges that bounced and jiggled as they leapt and landed, like tumorous tutus.

Rei Kawakubo remains dedicated to creation, newness, and progress more than fifty years after she first started making clothes. Her career and influence were celebrated at the Metropolitan Museum of Art's Costume Institute Gala in 2017. She was only the second living designer to be chosen, and the "Art of the In-Between" exhibit was both a retrospective and a finely curated homage to her career.

Kawakubo is famously inscrutable. She doesn't mention her influences or intentions in interviews, instead speaking to ideas of art, society, and personal expression. "Continuing in a state of perplexity is a risk. Advancing ahead while fumbling around in the dark is also a risk. I believe that Comme des Garçons should choose the latter."

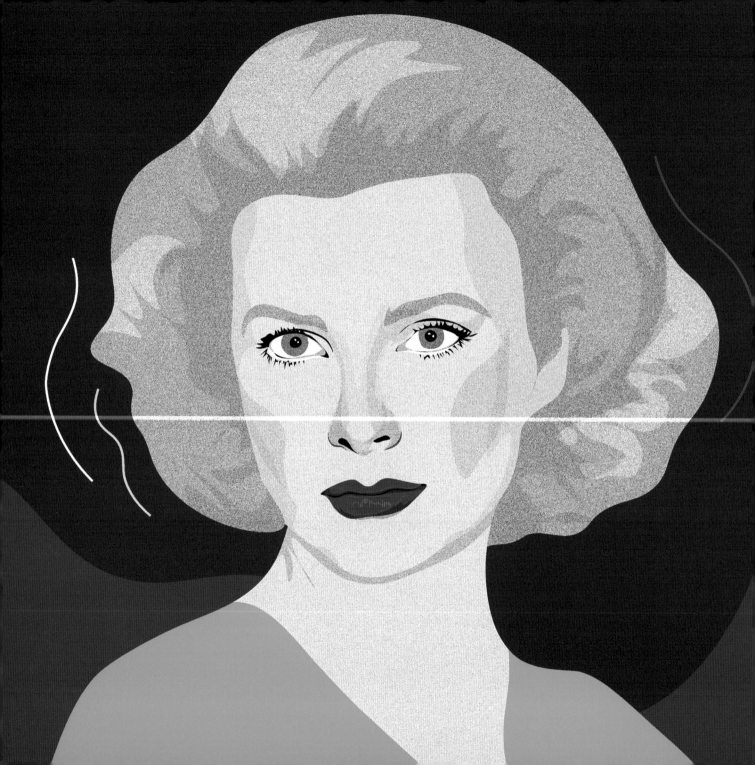

GRACE KELLY

It took just five years for Grace Kelly to make her mark on Hollywood, her luminous beauty and style as unforgettable as her classic roles. From 1951 to 1956, she graced the screen in more than eleven films, including *Rear Window*, *High Society*, *Dial M for Murder*, and *To Catch a Thief*. Her co-stars from that period exist in the pantheon of Hollywood leading men—Jimmy Stewart, Cary Grant, Bing Crosby, Gary Cooper, and Frank Sinatra, to name a few. She worked with Hollywood royalty before she became a princess herself, directed by Alfred Hitchcock and John Ford, and dressed by Helen Rose and Edith Head. And then, just as suddenly as she had appeared, she was gone, whisked away to Europe to become Her Serene Royal Highness, Princess Grace of Monaco.

Grace Kelly was born into great wealth and privilege, the third of four children raised in Philadelphia by parents who prided themselves on being healthy and hale. Grace was a bit different—she was imaginative and quiet in a family of boisterous, outgoing athletes. Her father won Olympic medals for rowing, her mother was the first woman to teach physical education at the University of Pennsylvania, and Grace's siblings all followed suit. But Grace preferred the stage to the athletic pitch, and when she decided to pursue a career in acting, her parents were somewhat dismayed. They felt acting wasn't an appropriate career choice for an upper-class young woman. Grace prevailed and, with the help of her Pulitzer Prize-winning playwright uncle, she enrolled in the American Academy of Dramatic Arts in New York.

Grace's first big break in Hollywood came in 1953 with *Mogambo*, opposite Clark Gable. The next year found Grace starring in five films—two of them Hitchcock classics—and garnering her first Academy Award win for Best Actress for *The Country Girl*. Bob Hope opened the Oscars the following year with a joke that a new award was being given, "a special award for bravery for the producer who made a picture without Grace Kelly."

But she abruptly left it all for love. Grace Kelly met Prince Rainier III at the Cannes Film Festival in April 1955, and the two wed a year later. She secured the Grimaldi family's reign for the next generation when she gave birth to her first child, Caroline, in January 1957. Ever discreet and private, Grace had used her Hermès handbag to shield her pregnancy from the paparazzi. Thus, the "Kelly bag" was born.

Grace gave birth to her son, Albert, in 1958, and her daughter Stephanie in 1965. In addition to raising her children and performing her royal duties, Grace established a foundation supporting children globally, as well as a foundation that supported the arts in Monaco. She died at the tragically young age of fifty-two, in a car accident.

She possessed classic beauty, perfect manners, impeccable taste, and matchless style. As fate would have it, even while wearing white gloves, Grace Kelly was still capable of leaving a lasting mark.

YAYOI KUSAMA

Yayoi Kusama was born in Japan in 1929, and she began making art when she was ten years old. She was mentally ill, and her best-known art is a continuation of her earliest attempts to make sense of her hallucinations, when she would see her world covered in dots. She has created polka-dotted everything—from paintings and sculptures to entire rooms, clothing and bags, and even human bodies.

Her parents forbade her from creating art when she was a young girl, as they believed being an artist wasn't appropriate, especially a woman. They were unsympathetic to the palliative effect art had on her, and went so far as to take away her art supplies. They wanted her to marry well, as her older sister had done. Yayoi attended art school against her parents' wishes and after achieving some critical success in Japan, she moved to New York in her late twenties to see if her art would have meaning in what she felt was the center of the art world.

It did. Yayoi was at the forefront of the cultural shift of the 1960s. She had gallery shows, mounted happenings and anti-war demonstrations, held fashion shows, and created immersive art experiences including body painting festivals. In 1966, she staged an event outside a pavilion at the Venice Biennale called *Narcissus Garden*. The work was made up of hundreds of small reflective orbs that reflected a distorted view of both the viewer and the surroundings. Like so much

of Yayoi's art, it caused a stir and some controversy. She was eventually forced to shut it down when she began selling the individual balls outside the Biennale pavilion—her own comment on the mechanization and commodification of art. Take that, Banksy.

Yayoi's Infinity Room installations subsume the viewer in an unending reflection of both the viewer and of hundreds of thousands of tiny specks floating in space. She seems to continue to ask the question, what can one life mean in an ever-expanding universe? Yayoi returned to Japan in the late 1970s, and voluntarily checked herself into a mental hospital, where she has lived ever since. She has a studio nearby where she goes every day to make art, and to write poems and stories.

The art world is fickle and prone to short-term memory loss. While Yayoi has consistently shown internationally throughout her career, it wasn't until a retrospective was mounted in 1989 at the Center for International Contemporary Arts in New York that her artistic contributions were historically cemented. Mental illness was her springboard to creativity, and through her art she addressed race, gender, sexuality, and the concept of infinity. Born into a patriarchal society, and without the encouragement or support of her family, Yayoi went on become one of the most important artists of her era.

JENNIFER LOPEZ

J. Lo does it all. She sings, she dances, she acts, and she produces. She's a business woman and a branding maven, a Puerto Rican girl from the Bronx, living the good life in Bel Air. Jenny from the Block "went from a little to a lot."

Jennifer Lopez was a performer from the start. She took singing and dancing lessons as a child, and when she saw a casting notice near her high school, she tried out and landed a part in a small film. After high school she went to work as an actress and dancer, and her first big break came when she was cast as a backup dancer on television's *In Living Color* in 1991. She left after a couple of years to try to for a movie career, establishing the pattern early in which she succeeds . . . and then she's onto the next thing.

As Jennifer began making movies her profile rose, culminating in 1997's megahit, *Selena*. With the movie, which detailed the singer's meteoric rise and tragic death, Lopez was said to be the first Latina actor to be paid a million dollars for a film. She went on to work with high-profile directors like Steven Soderbergh and Oliver Stone, starring opposite the likes of George Clooney and Sean Penn. Hollywood was hers for the taking.

So, Jennifer decided to try out the recording industry. She released her debut album, *On the 6*, in 1999 to widespread acclaim. When her second album, *J. Lo*, was released the same week as her movie *The Wedding Planner*, she was one of the first artists to have a number one movie and number one album in the US in the same week. Critics who'd wagged their fingers at the audacity of an actress going for a singing career were silenced. Jennifer had proved her mettle.

Tabloid culture was ascendent and Jennifer was often front-page news. The green Versace dress she wore to the Grammy Awards in 2000 was the stuff tabloid editor dreams are made of. So were her romances, her successes, and her failures. She weathered many a front-page storm, all the while continuing to expand her empire with fashion, fragrance, and cosmetics deals; television and movie roles; albums; and live performances. She has done a Vegas residency, was a judge on *American Idol*, founded a production company, and has designed her own clothing lines.

She is a mother to twins, and an outspoken advocate for the #MeToo movement. Her philanthropic work is as evident and varied as her talent—she's received awards from GLAAD, the Human Rights Campaign, amfAR, and Amnesty International, among many others.

All the while, Jennifer stayed true to herself. From the start of her career, she claimed her biggest success was in staying grounded. Her warmth and her work ethic always shine through, no matter what the project. It's anyone's guess what her next achievement will be—but if old habits really do die hard, one thing is certain: she'll make a success of it.

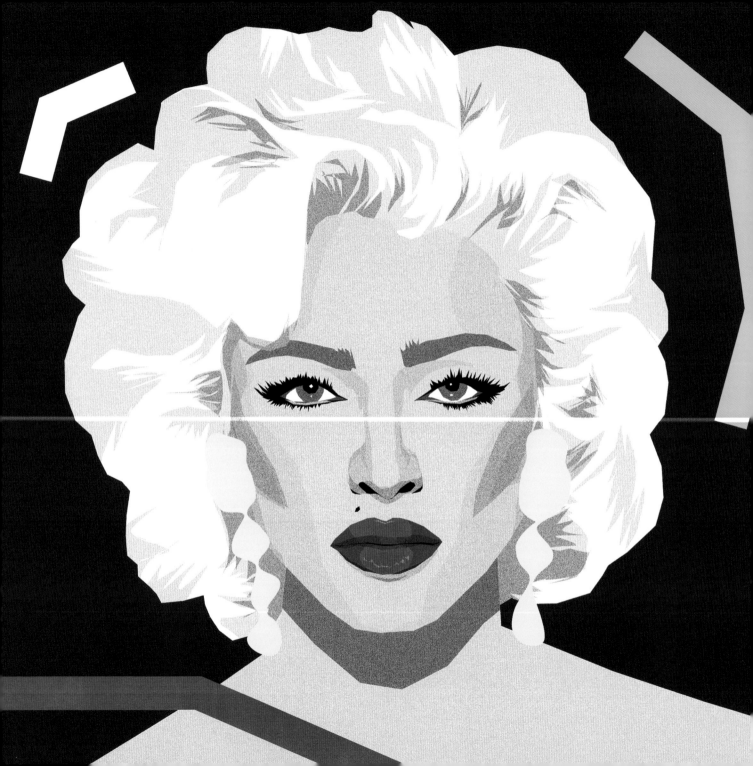

MADONNA

Madonna is the mistress of reinvention. She has gone from Catholic school girl to downtown dancer, from pop star to stage actress, from dating Dennis Rodman to being the mother of six children. Outrageous and irreverent in youth, reflective and spiritual in her later years, she has managed to maintain cultural relevancy long after her contemporaries were banished to the sidelines. Whether it's due to her talent for songwriting or for self-aggrandizement isn't clear, but she's got a knack for pushing society's buttons, and for provoking people to respond to her art.

When Madonna exploded onto the scene with her eponymous album in 1983, rubber bracelets and giant hair bows were suddenly a thing. "Lucky Star" and "Borderline" topped the charts. Madonna performed "Holiday" on *American Bandstand*, famously telling Dick Clark she wanted to rule the world. "Like a Virgin" came out a year later, and the legacy of her groundbreaking iconography is never more evident than in her performance of the song at the MTV Video Music Awards. She wore full bridal regalia, dancing and writhing on stage in a way that many felt was far too sexual and suggestive for the developing minds of young teenagers. Thirty years and many provocative female pop stars later, that outrage seems almost quaint.

But that is part of Madonna's gift. Like an older sister who breaks in the parents so that the younger siblings have an easier time of it, Madonna did much of the heavy lifting when it came to normalizing conversations about sexuality and gender, introducing LGBTQ issues to the mainstream, and most of all, pushing the boundaries for what's "acceptable" for young women.

With her last album of the eighties, *Like a Prayer*, Madonna leaned further into the iconography and traditions of Catholicism. The album's final track, "Act of Contrition," was just that—Madonna recites a Catholic prayer that is said as penance. But rather than whispering in church, Madonna happens to be reciting the prayer over a guitar solo by Prince.

Spirituality and religion weren't only marketing ploys. Madonna delved deeply into the Judaic teachings of Kabbalah in her personal life. She married twice, and though both marriages ended in divorce, she is mother to six children, four of whom she adopted from Malawi. She became active philanthropically in her adoptive childrens' home country through her foundation Raising Malawi, and also remains a committed ally to the LGBTQ community. She received the GLAAD Advocate for Change Award and was named a Stonewall Ambassador in 2019.

Madonna's influence can't be overstated. Her tours and records are some of the highest grossing in the music industry, and her longevity is legendary. If the current climate of one-hit wonders and YouTube stars is here to stay, it could be that Madonna is the last of a dying breed. Long live the Queen of Pop.

MARILYN MONROE

Sex sells, and Marilyn Monroe knew it. Throughout her career she wielded her image like a finely honed knife, having grasped early what it would take to make it in Hollywood. She willingly underwent a transformation at the start of her career, changing her name, dying her hair, raising her hairline, and undergoing plastic surgery. Though her life is often used as a cautionary tale against falling victim to the star machine, Marilyn would have made a killer publicity agent if she hadn't been so intent on an acting career. This was a woman who, having spent her childhood in California's foster care system, entered a marriage of convenience at sixteen to escape it. Once she was making enough money to support herself, she escaped the marriage too. Marilyn Monroe had her head in the game from the very start.

Marilyn's first big break came in 1953 with *Niagara*, the film that was publicized with an extended shot of Marilyn's hips swaying seductively as she walked away from the camera. She performed "Diamonds are a Girls Best Friend" that same year, swathed in a pink dress, surrounded by debonair young men. It was also in 1953 that Hugh Hefner launched his new magazine, *Playboy*, with Marilyn on the cover. He used nude photos of her for the centerfold and Marilyn, sensing negative press was coming, explaining that she'd been very hard up for money when the photos were taken. Her tactic worked; the public sympathized a young woman's plight and she breezed through the potential scandal.

Once Monroe's standing in Hollywood was firm, she took her fame and used it in contract negotiations. When the studio balked, she walked away from a role in a film she was contractually obligated to play. Again sensing the possibility of public disapproval, she married her longtime boyfriend, Joe DiMaggio, amidst a flurry of public attention, and she sang for US troops stationed in Korea at the tail end of her honeymoon. When she returned to the states, Marilyn founded a company of her own: Marilyn Monroe Productions. The studio recognized her PR savvy as well as her worth, and Marilyn signed a plum contract in 1955, giving her creative control in her films and a lot more money.

Marilyn's marriage to DiMaggio fell apart and she married playwright Henry Miller in 1956. The press called the couple "the hourglass and the egghead," but Marilyn had found a man who saw her for the dramatic actress she aspired to be. She began taking serious roles and receiving rave reviews, but her personal life was unraveling. Her drug and alcohol use were proving self-destructive. Miller and Monroe divorced and a spate of health issues ensued. Marilyn died in August 1962, the same year she so famously sang "Happy Birthday" to President John F. Kennedy. Though Marilyn's addictions overcame her, she was never the dumb blonde she appeared to be. Lorelei's line in *Gentlemen Prefer Blondes* was Marilyn's own addition. "I can be smart when it's important, but most men don't like it."

LUPITA NYONG'O

Lupita Nyong'o has taken Hollywood by storm. She won an Oscar right out of the gate, filmed in A Galaxy Far, Far Away, became a Disney darling, and proudly proclaimed "Wakanda Forever!" She raps with the best of them, and wears clothes like every day is her own personal runway. When it comes to important issues, she's not afraid to speak her mind.

Lupita was raised in a loving family of high achievers in a middle-class suburb in Kenya. She went to college in Massachusetts and studied at the Yale School of Drama. None of those facts could have prepared audiences for what she brought to her first feature film, *12 Years a Slave*. When Lupita won an Academy Award for Best Supporting Actress for her portrayal of Patsey, she navigated the ensuing press storm with a strength of character unusual in such a newly minted star. Growing up a politician's daughter had heightened her sense of her public self and her private self, and that awareness served her as she navigated the scrutiny and publicity attendant to her newfound fame.

Lupita was born while her parents were living in Mexico. Her father was a pro-democracy politician and the family left Kenya during a period of political strife. They returned to Kenya shortly after Lupita's birth, and it wasn't until she was a teenager that she lived in Mexico again. She speaks of the time she spent in the tiny town of Taxco as formative. In addition to living away from her parents for the first time, Lupita experienced "otherness" for the first time, because of the color of her skin.

Lupita is an outspoken advocate for representation and diversity in Hollywood, and she is aware of her outsider's perspective as an African woman navigating the system. "[My work] is not limited to Africa, but Africa is my first paradigm so it's something I feel a little starved for. Now that I have some small platform, I want to use it tell those stories."

Lupita has been specific in her post-Oscar choices. She made her off-Broadway debut in *Eclipsed*, and her star power helped bring the play to Broadway. The story of five women's experiences during the Second Liberian Civil War was nominated for five Tony Awards. In addition to performing on stage and in dramatic roles, Lupita's forays into horror and comedy were well received. She was mesmerizing in Jordan Peele's *Us*, as both a terrifying woman intent on killing, and the terrified doppelganger who is her main target.

Lupita was the first black woman to sign with Lancôme as a brand ambassador. When she says she likes to try different things, she means it. Her role as Nakia in *Black Panther* has been her highest profile to date. Lupita set out to praise the film's director for his portrayal of women, when she said, "They're layered, complex, and have agency." While it's a beautiful testament to the powerful women of Wakanda, it's difficult to read the quote and not think of Lupita.

MICHELLE OBAMA

That Michelle Obama is most famous for her role as First Lady of the United States is proof enough that the Office of the President is in a category of its own. How could a woman who rose to the top of her class through grade school and high school in Chicago's public school system, who went on to graduate cum laude from Princeton University, and then from Harvard Law School, who had a career with a prestigious law firm before leaving to put her prodigious talents into so effectively helping others achieve greatness—how could this incredibly accomplished woman be overshadowed by anyone or anything?

Long before she was mother to Malia and Sasha, Michelle Obama knew that helping young people realize their potential was principal to her mission in life. Very early in her law career, Michelle realized she wanted to recommit herself to the city and people of Chicago. She left Chicago's Sidley Austin and began working in planning at development at City Hall. She went on to be the founding Executive Director of Chicago's branch of Public Allies. This role was an early clue of what was to become one of Michelle's missions—connecting young people with their passions so they would realize their potential to positively influence the world around them. That somewhere along the way she fell in love with a passionate and talented young lawyer who was committed to community organizing came as no surprise, though when they landed in the White House with their two young daughters, Barack and Michelle Obama began an altogether different chapter of their lives together: as the first African American First Family.

Michelle continued her work in support of children and communities with her initiatives as First Lady. Healthy eating and exercise, education, and youth empowerment were all priorities during her time at the White House, though she also found an entirely new calling. Through meeting with members of the military, Michelle realized the depth and breadth of struggles that active and retired members of the military and their families face, and she put those issues at the forefront of her work. In addition to raising two accomplished young women, Michelle has spent her career thinking about and working towards ways to help other people become their best selves. All the while, Michelle Obama herself has been *Becoming* a cultural icon as her popularity and best-selling memoir can attest.

ALEXANDRIA OCASIO-CORTEZ

In the 2018 elections, Alexandria Ocasio-Cortez, American by birth and Puerto Rican by heritage, defeated the white, male, ten-year incumbent in New York's 14th congressional district, delivering one of the biggest upsets of the midterms. "AOC" was part of a wave of incoming freshmen in the US House of Representatives, and the youngest woman ever to serve in Congress. She was almost instantly one of the loudest voices coming from those hallowed halls.

Alexandria grew up in the Bronx and Yorktown. Her mother cleaned houses and her father was a small business owner. She attended public school through high school, and graduated cum laude from Boston University. She worked in education and community organizing after graduation, and as a waitress and bartender. After the 2016 election, Alexandria met members of the Lakota Sioux tribe in Standing Rock. She realized the importance of standing up for your community, and taking the steps necessary to protect it. She started on the path to the House of Representatives the very next day.

Along with three other female candidates running for Congress in 2018, Alexandria was featured in the Netflix documentary *Knock Down the House*. Alexandria was the only one of the four to win a seat, all but proving her point that, "For one of us to make it through, one hundred of us have to try."

Once in office, she became a force to be reckoned with—one not easily labeled or contained. She became the bogeyman of the right, so vocal and assured of herself, she was unflappable in the face of the constant criticism lobbed at her on a daily basis. Instead of dissuading her, the challenges seemed only to spur Alexandria on. She continued to work toward legislation on her key platforms: housing, Medicare, jobs, criminal justice reform, the abolition of ICE, and free college tuition, among others. She wielded social media like the weapon that it is, savvy enough to use Twitter to her advantage, and witty enough to slap back at any who challenged her supremacy on the platform.

While AOC claims she doesn't think she'll be in government forever, it's hard to imagine she'll disappear anytime soon. She's got a fire in her belly and, even in her short life, she's experienced enough to know how important it is that our government protect and care for all of its citizens. Of her time spent waitressing, she said, "The thing that people don't understand about restaurants is that they're one of the most political environments. You're shoulder-to-shoulder with immigrants. You're at one of the nexuses of income inequality. Your hourly wage is even less than the minimum wage. You're working for tips. You're getting sexually harassed. You see how our food is processed and handled. You see how the prices of things change. It was a very galvanizing political experience for me." If she saw and learned that from a straightforward waitressing job, just imagine the insights she'll have made after a couple of years in Congress.

69

QUEEN ELIZABETH II

Her Majesty the Queen. It's not the title Elizabeth Alexandra Mary Windsor was born to inherit. When she arrived on April 21, 1926, her parents were the Duke and Duchess of York, and they would likely have remained so if it weren't for a certain American divorcée. When King Edward VIII abdicated to marry Wallis Simpson, Elizabeth's father, Bertie, became King George VI, and Elizabeth—a mere ten years old at the time—became first in line to the British throne.

Queen Elizabeth was born to a life of privilege; she is a Windsor after all. But by all accounts, she was a sensible and practical child. She loved dogs and horses—two passions she maintained throughout her life—and she was a Girl Guide, a Sea Ranger, and a competitive swimmer. Once it became clear that Elizabeth would one day be Queen of England, she was given extra tutoring. In particular, she studied constitutional law and religion. While anyone with an interest was free to delve into such heady subjects, Queen Elizabeth was perhaps the only young woman to be tutored on the Church of England by the Archbishop of Canterbury himself.

Queen Elizabeth was thirteen when England entered the Second World War. When it was suggested that she, her sister, Margaret, and their mother might be evacuated, the Queen Mother famously replied, "The children won't go without me. I won't leave the King. And the King will never leave." So the princesses and their parents remained in England for the duration of the war. "Duty first" was instilled in Queen Elizabeth from the start.

When Queen Elizabeth married Prince Phillip in 1947, she was just twenty-one years old. Prince Charles was born a year later, and Princess Anne in 1950. The brief idyll of "normal" family life ended when King George died in 1952, and Queen Elizabeth ascended the throne. Margaret cried at Elizabeth's coronation, saying, "I've lost my father, and I've lost my sister. She will be so busy. Our lives will change." Queen Elizabeth raised four children while stewarding her country through good times and bad. Andrew was born in 1960 and Edward in 1964. In a small acquiescence to her new dual role, Her Majesty moved a standing five thirty meeting on Tuesdays back one hour, to six thirty. The new start time allowed the Queen to be there for her children's six o'clock bedtime routine—the Prime Minister of England could wait.

Queen Elizabeth has been a bastion of the British monarchy since 1952. She is the longest reigning monarch in British history, she is patron or president to more than 600 charities, and her steadfast nature and calm demeanor have steadied the British people in troubled times. Her unwavering dedication to a life of service and ceremony has made her a near perfect head of state. She is reliable and unwavering in an increasingly volatile world, and her subjects and admirers across the globe are all the better for her reign.

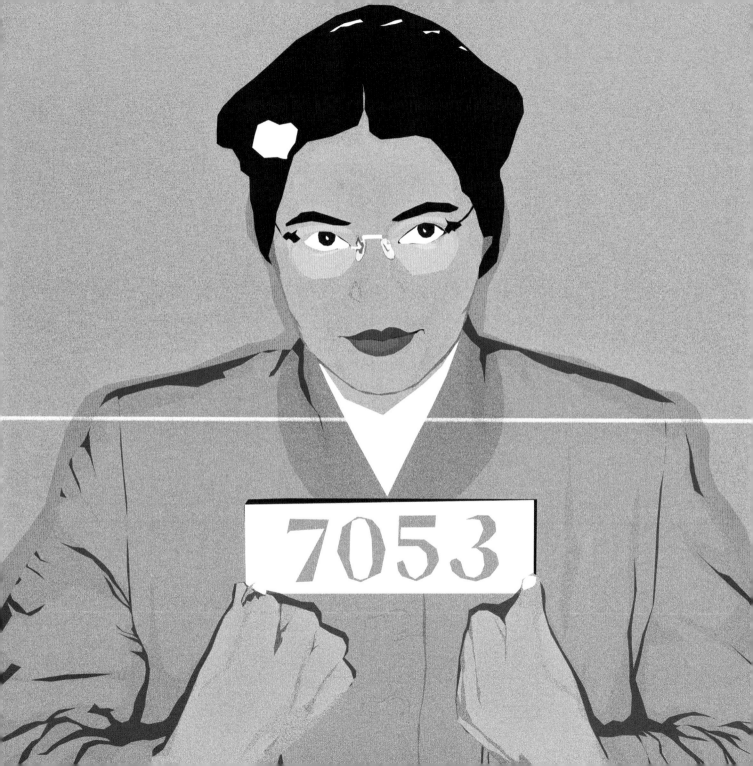

ROSA PARKS

Rosa Parks wasn't actually seated in the front of the bus on that December day in 1955. She was seated in the middle, where both whites and blacks were allowed to sit. But the bus was full and a white passenger was standing, so the driver asked Rosa and a few other African Americans to stand so the white man would have a seat. By law, they were required to clear an entire row in the middle section if a white person wanted to sit down. The three other people in Rosa's row stood. Rosa did not, and she was arrested. She has since said of that day that she decided "to let it be known that I did not want to be treated in that manner, and people had endured it far too long."

Rosa was born in 1913 in Tuskegee, Alabama. Her mother, Leona, was a teacher and her father, James, was a carpenter. Rosa spent much of her childhood living with Leona's parents in Pine Level, Alabama. She attended school up to and including teacher's college. When her grandmother fell ill, Rosa quit college to care for her. Rosa married Raymond Parks and the couple became active in the civil rights movement in Montgomery. Before she refused to give up her seat on the bus, she had worked on cases for the NAACP involving lynchings, rape, and murder. None sparked the flame like her singular moment of nonviolent protest.

News of Rosa's arrest spread, and members of various civil rights organizations in Montgomery decided the moment was right for a citywide bus boycott. The one-day boycott was successful and at a meeting held later that night, the Montgomery Improvement Association was formed. The group voted unanimously to extend the boycott until the law was changed. A twenty-six-year-old preacher was named president of the MIA, based on his calm demeanor and his oratory skills, and because having just arrived in town the year before, he was relatively unknown in Montgomery outside the African American community. His name was Martin Luther King, Jr.

Over a year later, after much work and a lot of turmoil in the lives of Rosa and her colleagues, the Montgomery Bus Boycott ended when the Supreme Court upheld an Alabama district court ruling that segregation on Alabama's buses was unconstitutional.

Rosa Parks remained an active and celebrated member of the civil rights movement until her death. She walked in the Selma to Montgomery March in 1965. She joined the staff of US Representative John Conyers upon his election to Congress in 1964. Rosa Parks received the Presidential Medal of Freedom and a Congressional Gold Medal. She established the Rosa and Raymond Parks Institute, with a mission to educate and inspire children to reach their highest potential. When Rosa Parks died in 2005, her casket was placed in the Rotunda of the US Capitol. She was the first woman and the second African American to receive the honor.

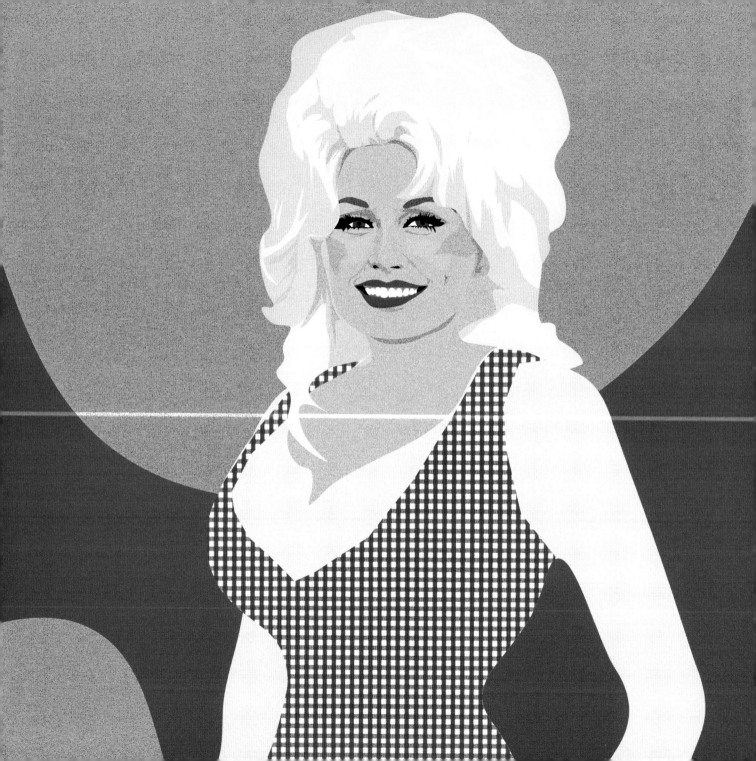

DOLLY PARTON

Dolly Parton started writing songs when she was seven years old, and she was performing by the time she was ten. She has been nominated for Emmys, Grammys, Oscars, and a Tony. She has received a Kennedy Center Honor, the Living Legend Medal awarded by the US Library of Congress, and the National Medal of Arts. She was inducted into the Songwriters Hall of Fame, she received the Lifetime Achievement Award from the Grammys, and she was inducted into the Country Music Hall of Fame. She built Dollywood, she founded the Dollywood Foundation, and she started the Imagination Library. She wrote "I Will Always Love You" and "Jolene." She starred in *Steel Magnolias* and *9 to 5*. In addition to her singing and songwriting prowess, she plays guitar, fiddle, banjo, autoharp, piano, dulcimer, and electric guitar. The list goes on, and on, and on.

But what does everyone talk about? Her *appearance*. Because that's what this preternaturally gifted, hard-working, philanthropic, and lauded woman is famous for.

But Dolly Parton doesn't seem to mind. She just goes about her work, throwing off quips that are almost as famous as she is. From "It costs a lot of money to look this cheap" to

"I'm not offended by all the dumb blond jokes because I know I'm not dumb, and I know I'm not blond." Dolly has always let everyone know she's in on the game. She has inspired countless singers and songwriters (Dolly did the country-pop crossover long before others made the leap); fought against female stereotypes and discrimination in the workplace (*9 to 5*, anyone?); and has been a fierce advocate and supporter of children's literacy on a global scale (the Imagination Library gives a free book to a child between the ages of zero and five every two seconds).

"I Will Always Love You" is arguably one of Dolly Parton's most famous songs. What's lesser known is that she wrote it not for a lover but for a man who, in modern parlance, would be known as her "work husband." The two writing partners were going separate ways professionally, they had had great success together, and she wanted him to know how much he meant to her and that she would never forget him. All the hallmarks of the life Dolly Parton has built for herself—hard work, love, loyalty, compassion, and staying true to yourself—are encapsulated in that one nearly perfect song.

We will always love you, Dolly.

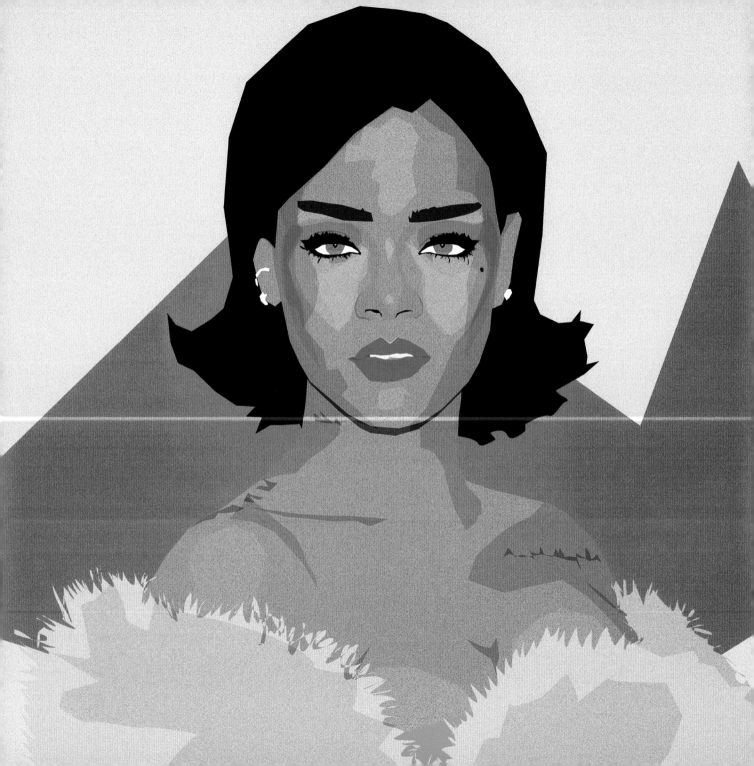

RIHANNA

Robyn Rihanna Fenty was born in Barbados in 1988. She formed a band with friends when she was a teenager, and when a New York record executive came to Barbados on vacation, Rihanna and her friends managed to get an audition. Rihanna impressed the man enough that she and her mother were soon on their way to the US to record demos. Rihanna moved to New York soon after, and signed with Def Jam Recordings. Looking back on that time, Rihanna has said that the process was a stifling one for a young girl, though it led to her successful career. She felt she didn't have the chance to figure out who she wanted to be, because she was consumed with being whom the label wanted her to be.

"I got really rebellious," she recalls. "I was being forced into a particular innocent image and I had to break away from it."

Enter Bad Girl RiRi. Stylistically, Rihanna adopted an edge. Her third album, 2007's *Good Girl Gone Bad*, veered away from the Caribbean influences heard on her first two albums and instead reveled in the rock and dance influences she had picked up while living in the states. Her single off the album, "Umbrella," earned Rihanna her first Grammy. Rihanna worked steadily through 2008, collaborating with musicians and releasing more songs. In early 2009, she was the victim of domestic abuse in a case that went public, due to leaked photos of the singer after the assault. Rihanna channeled her emotion into her music and 2009's *Rated R* was incredibly well received. While it was darker in tone than her previous albums, the complexity and creativity that went into making it translated to fans and critics alike.

Rihanna has extended her reach far beyond pop music. She started working on fashion collaborations in 2011 and has worked with the likes of Armani, Puma, and Dior; she launched a fragrance line; she is a co-owner of the music streaming service, Tidal; she launched a beauty and stylist agency; and she launched a make-up company called Fenty Beauty, a lingerie company called Savage X Fenty, and a fashion brand called simply Fenty. Fenty Beauty is a company that disrupted decades of status quo within the makeup industry with the novel concept of selling foundation for all types of skin, instead of just pale, paler, and palest. Rihanna says memories of her mother applying foundation were the inspiration—she didn't consider it a political statement, though it was heralded by the press as one.

Rihanna has established two foundations and has been involved in countless charity collaborations. She has pursued an acting career, with starring turns in *Oceans 8* and *Guava Island*. She co-chaired a Met Gala. And she hasn't stopped putting out albums. Rihanna lives the songs she sings. *Work, work, work, work, work, work.*

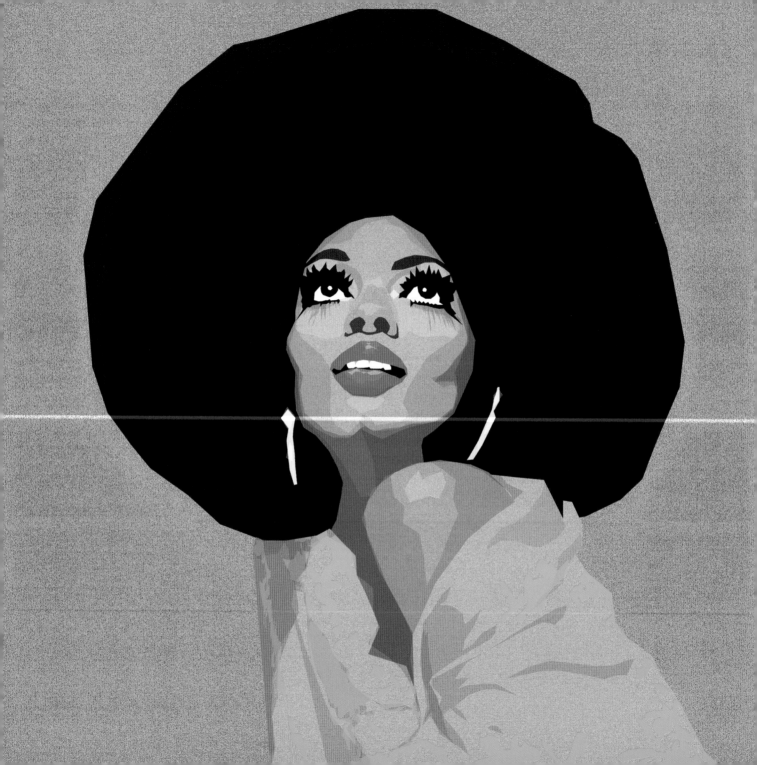

DIANA ROSS

Diana Ross remembers her childhood in Detroit as full of song. Aside from sitting outside on the front stoop with a radio, she also sang gospel at church. In fact, it was in the church choir when she was young where she met her future bandmates, Florence Ballard and Mary Wilson. The girls decided to form a group, and when a local boy band known as the Primes asked the girls to be their female counterpart, the girls agreed—and the Primettes were born.

Diana went to Cass Technical High School where she studied fashion in addition to the rigorous curriculum. The Primettes auditioned at Motown and, though they weren't allowed to tour until they finished high school, they would go to the studio to sing backup for the label's other recording artists. When they signed with Motown in 1962, they changed their name to the Supremes.

The Supremes helped define the 1960s Motown sound with hits like "Where Did Our Love Go," "Stop! In the Name of Love," and "Someday We'll be Together." They had ten number one singles between 1964 and 1967, and when Florence Ballard was replaced with Cindy Birdsong in 1967, the band was renamed Diana Ross and the Supremes. In January 1970 Diana Ross performed her final show with the Supremes in Las Vegas. She launched her solo career that spring, first with "Reach Out and Touch (Somebody's Hand)," followed by her chart-topping cover of "Ain't No Mountain High Enough."

If the 1960s were about the Supremes, the seventies were about Diana Ross. Diana married music executive Robert Ellis Silberstein in 1971 and soon gave birth to daughters Rhonda, Tracee, and Chudney. Diana played Billie Holiday in *Lady Sings the Blues*, garnering herself an Oscar nomination for Best Actress. She continued acting throughout the 1970s, starring and singing in *Mahogany* and cult classic *The Wiz*. When Diana co-hosted the Academy Awards in 1974, she was the first African American woman to do so.

Diana released her tenth studio album in 1980, and her song "Upside Down," went to number one on the charts. A second song off the album, "I'm Coming Out," has been adopted as an anthem of the LGBTQ community. *Diana* was her last album with Motown, and when Diana signed with RCA in 1981, it was the music industry's most expensive recording deal in history. She returned to Motown a few years later, negotiating partial ownership of the label as part of her contract. She married her second husband, Arne Naess Jr., in 1985, and they had two sons together, Ross and Evan.

Diana Ross's impressive career spans more than fifty years, and her legendary status in the music industry reflects it. She has been honored at the Kennedy Center and was awarded a Grammy for Lifetime Achievement, and she received the Presidential Medal of Freedom, among countless other awards. She credits her longevity to "the love and joy of performing. The harmony of life. The love of family."

J.K. ROWLING

After graduating from college, J.K. Rowling worked at Amnesty International in London. This preternaturally talented woman, who wrote the best-selling book series in history, whose novels have been translated into over eighty languages, and have sold more than 500 million copies—she calls the relatively short period of time that she worked in the African research department at Amnesty International the most formative experience of her life. She bore witness, through personal accounts and handwritten letters, to the most barbaric and tragic aspects of humanity. She saw evil up close, as well as its counterpart, human goodness. Then she conjured Harry Potter.

J.K. Rowling singlehandedly created an entire generation of readers. Children who might have otherwise spent afternoons staring vacantly at a screen instead rushed home from school to crack open one of her books, entering a world so fully realized, so humane and funny and startling that they lost entire afternoons to Boggarts and Dementors, the Weasley twins and their epic pranks, and of course Harry Potter's singular burden as the boy who lived.

Before achieving dizzying heights of fame, success, and wealth, Joanne Rowling (pen name, J.K.) was a self-proclaimed bookworm. She wrote her first novel when she was eleven years old, and she studied the classics in college. As a single mother, she was "as poor as it is possible to be in modern Britain, without being homeless." Now that she is one of Britain's wealthiest women, she has embraced philanthropy with gusto. She established charitable trusts Lumos and Volant, and through them she supports causes both in Britain and internationally.

Joanne Rowling has more than one pen name, and writes in more than one genre. Writing as Robert Galbraith, she published her first crime novel in the Cormoran Strike series, *Cuckoo's Calling*, in 2013. She has continued the series and says she'll keep writing them as long as she has stories to tell. Rowling works in film as well; she has written the original screenplays for the Fantastic Beasts series. Her foray into theater resulted in *Harry Potter and the Cursed Child*, a play in two parts that picks up nineteen years after the final Harry Potter novel, *Harry Potter and the Deathly Hallows*.

J. K. Rowling gave the commencement speech at Harvard University in 2008. She stood before the graduating class and preached the benefits of failure, and the importance of imagination to students who had literally grown up with Harry, Hermione, and Ron. She spoke of the importance of friendship, specifically the friendships she made in college. She told the graduates, "You will never truly know yourself, or the strength of your relationships, until both have been tested by adversity. Such knowledge is a true gift, for all that it is painfully won, and it has been worth more than any qualification I ever earned." Dumbledore couldn't have said it better himself.

NINA SIMONE

Nina Simone was born Eunice Kathleen Waymon in North Carolina in 1933. Her parents were poor, but when she displayed a prodigious talent for the piano, she was given lessons. She aspired to a career as a classical pianist, and a local fund was established to help pay for her to continue her musical education. She studied at Juilliard and went on to apply for entrance to the prestigious Curtis Institute of Music in Philadelphia. She wasn't admitted, and later voiced a belief that the decision was racially motivated.

Nina began playing piano in bars and nightclubs in New York and New Jersey to earn money. Knowing her parents would disapprove of her for playing popular music, she came up with the stage name Nina Simone. Her musical style was a mix of her influences—ranging from classical piano to jazz and the blues, peppered throughout with references to pop music as well as standards like Gershwin and Cole Porter. She had recorded both studio and live albums and her star was on the rise when the racial unrest of the period and the civil rights movement sent Nina in a different direction.

"Mississipi Goddam" marked a new era in her music. The bombing of the 16th Street Baptist Church in Birmingham, Alabama and the murder of civil rights activist Medgar Evers were inspiration for the song, which she recorded and released on an album in 1964. While she'd initially balked at using her music to address the social issues of the day, because she felt it demeaned important issues to reference them in popular music, the two events proved too important for her to ignore. Her career as a popular singer took the backseat to her burgeoning role as social activist.

Nina Simone devoted much of her career to highlighting the ways in which American society was failing its African American citizens. She was an outspoken supporter of the civil rights movement, and aligned herself with poets and writers like Langston Hughes and James Baldwin—artists who concerned themselves with shedding light on societal wrongs and racial inequality. She co-wrote "To Be Young, Gifted, and Black" in memory of her close friend, playwright Lorraine Hansberry, whose play *A Raisin in the Sun* was the first written by a black woman to be performed on Broadway.

Nina Simone remained a staunch and outspoken activist for the rest of her life. She chose to reside outside of the United States beginning in the 1970s, and when she died in France in 2003 her ashes were scattered in Africa. Her career as a musician was, in many ways, affected by her activism. She was full of rage at the injustice she witnessed as a black woman in America, and it was that fire in her soul that fueled her creative output. She was difficult to define in a commercial sense, and while her musical career suffered for it, her legacy is that of an inspirational and powerful agent for change.

GLORIA STEINEM

When Gloria Steinem was born in 1934, women had had voting rights in the United States for only fourteen years. She was raised in Toledo, Ohio, and her mother, Ruth, had a career in journalism before Gloria was born. Ruth suffered a nervous breakdown, which made it difficult for her to work, and Gloria's childhood was marked by her role as caretaker to her mother. Her father, Leo, was a salesman, and when her parents separated when Gloria was ten, Leo moved to California, leaving Gloria and her mother in Toledo. Gloria attended school there, but finished high school in Washington D.C., where she lived with her older sister. She went on to Smith College, graduating Phi Beta Kappa in 1956. Gloria did governmental work for a few years before landing her first job in journalism at the satire magazine *Help!*

In 1962, Gloria was assigned to write an article on contraception for *Esquire* magazine. "The Moral Disarmament of Betty Coed" appeared in the September issue, alongside ads for men's shoes and overcoats. The article's closing paragraph begins, "The real danger of the contraceptive revolution may be the acceleration of women's role change without any corresponding change of man's attitude toward her role." Those were prescient words from a future leader of the woman's liberation movement, though it wasn't until she covered an abortion speak-out for *New York* magazine in 1969 that Steinem became serious about feminism.

The early 1970s saw her testifying before the Senate in support of the Equal Rights Amendment, and co-founding the National Women's Political Caucus and the Women's Action Alliance. When she and other journalists realized they couldn't get the articles published that they felt were important to women readers, they decided to found a magazine written for and run by women. *Ms.* magazine's first issue was a forty-page insert inside of *New York* magazine, and the cover featured a many-armed goddess holding objects in each hand to signify the many responsibilities of the modern woman. While there was initial uncertainty around whether *Ms.* would be a success, and worry that failure would be a blow to the women's movement, the first issue sold out its 300,000 copy run, and subscribers came pouring in.

While Gloria was already an established leader of the feminist movement when she co-founded *Ms.*, its political and societal significance elevated her profile. She has spent her career as a public and effective agent for societal change—on behalf of women, certainly, but also as a civil rights and anti-war activist, and a defender of basic human rights regardless of gender, race, or sexual preference. In 2005, she co-founded the non-profit Women's Media Center. She has received countless awards and accolades, including the Presidential Medal of Freedom in 2013, and her legacy as a leader of the women's movement is assured. But for Gloria, the accolades were never the point. "The primary thing isn't that they know who I am. It's that they know who they are."

MERYL STREEP

The story goes that Meryl Streep was horrified the first time she saw herself on screen—that she swore off movies for good as a result of her first role in the film *Julia*. One year later, she reversed her stand and accepted a part in *The Deer Hunter*, which garnered her her first Oscar nomination. More than fifty movies later, audiences can be grateful that in this one instance, Meryl Streep was not a woman of her word.

Meryl is the most nominated actor in the history of both the Academy Awards and the Golden Globe Awards. She has won three Oscars and nine Golden Globes, and she is so far out in front of the pack that she has become the butt of (loving) jokes during awards season. When she missed a ceremony due to illness, co-host Tina Fey joked, "Meryl is not here tonight, she has the flu . . . and I hear she's amazing in it."

Meryl was born and raised in New Jersey, and though she sang as a child and starred in musicals in high school, she didn't take dramatic acting seriously until she reached Vassar College. After graduating she enrolled in the Yale School of Drama, and then went to New York where she began auditioning for plays. Meryl performed in Shakespeare in the Park productions and Chekov plays before she eventually caught the notice of a Hollywood casting director when she debuted on Broadway in *Happy End*.

Though she's lauded for her dramatic performances, meaty roles like Sophie in *Sophie's Choice* and Joanna Kramer in *Kramer vs. Kramer*, Meryl's less serious parts prove her ability to bring depth to any character she chooses to portray. Miranda Priestly may not show her soft underbelly in the screenplay of *The Devil Wears Prada*, but Meryl's interpretation reveals the human behind the Chanel sunglasses. Hollywood's willingness to continue casting her as a leading lady long after the age when actresses usually get the boot is a testament to her talent. And Meryl delivers—she has had great commercial success in the last decade. The ABBA-inspired *Mamma Mia!* was such a hit they made a sequel ten years later, producing another delightful escape for audiences who wanted more of Meryl and her co-stars cavorting around a beautiful Greek island.

Meryl leads the pack in more ways than one. Her Cecil B. DeMille Award acceptance speech in 2017 was a politically charged call to arms, and in a moving display of support from the Hollywood community, she received a standing ovation at the Oscars a few weeks later. Meryl is an advocate for gender equality in Hollywood, and she has chosen to play powerful women like Margaret Thatcher and Katherine Post on the screen. Her acting is as moving and as relevant to audiences as it was when she started out, more than forty years ago. As Viola Davis said of Meryl, "Her artistry reminds us of the impact of what it means to be an artist, which is to make us feel less alone."

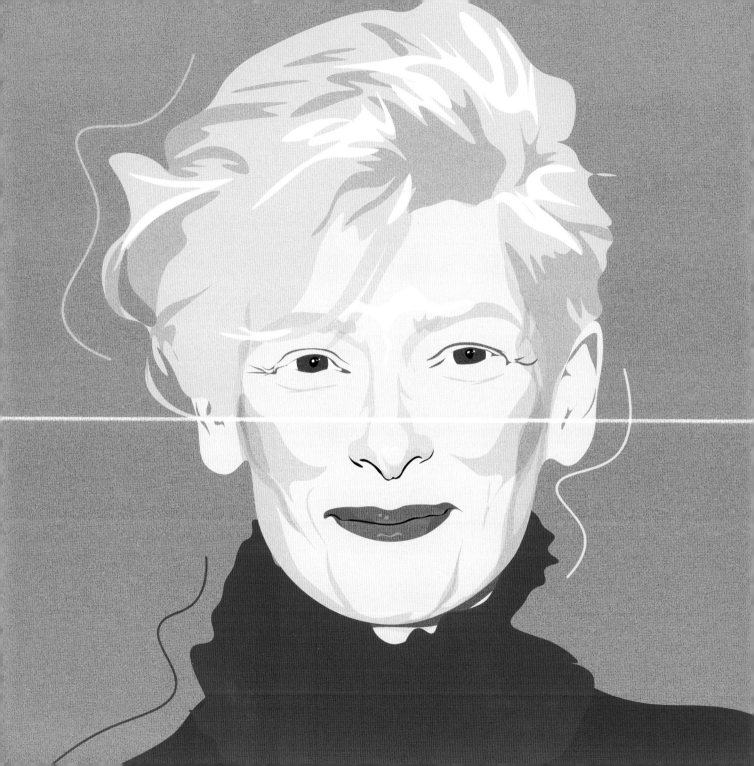

TILDA SWINTON

Tilda Swinton lives in the Scottish Highlands surrounded by vegetable beds and animals and men and children who love her. She claims her career, one studded with jaw-droppingly gorgeous performances, has been a distraction. Perhaps, she posits, she'll return to her first love: poetry. Whether she's inhabiting Virginia Woolf's Orlando or C.S. Lewis's White Witch, Swinton's talents seem aligned with those of a poet—her ability to reveal her character's inner workings is extraordinary.

Early on, she was a muse to the experimental filmmaker Derek Jarman, though it seems the relationship was likely more symbiotic than one-sided. In praising Jarman's ability to "sneak art into the mainstream," one can't help but think of Swinton's portrayal of Ancient One in the Marvel Universe. And in 2013, when she staged a performance art piece at New York's MoMA, titled *The Maybe*, sleeping in a glass case for eight-hour stretches over the course of a week—was it an actress taking a nap or was it art? Only the viewer could say.

Tilda Swinton is Scottish—very posh Scottish if ancient lineages are the measure—though she was educated mainly in England, hence her British accent. She attended Cambridge, where she studied English literature and took a brief shine to communism, in admiration of "the possibility of a combined effort." Perhaps the idea of a group working together drew her to film. She speaks of the "family reunion"-like aspect of film festivals, where the cast gathers together again long after the production has ended. Her movie choices are manifold, though she returns to art house directors like Jim Jarmusch and Wes Anderson again and again.

Her earliest forays into acting were about experimentation—and subverting expectation. There is a sort of mutability about the characters she has portrayed, until she begins to speak about her choices, and then a unifying theme becomes clear: " . . . it seems to me that the way you find the irreducible something at the center of human experience is to do all sorts of tests on it, to try to reduce it by attacking it with contradictions."

Those tests and attacks are the roles she takes in films. Think of *We Need to Talk About Kevin* versus *I Am Love*. She has played men and women and vampires; she won an Oscar for her portrayal of a career-driven corporate lawyer in *Michael Clayton*; she has taken on Shakespeare and the Coen brothers; she plays heartbreak and cold-hearted with equal passion. But in some ways, to call Tilda Swinton an actress would be to diminish her. Yes, she acts. She's also a performance artist, she's a Scot with a British accent, a wife with a boyfriend, a mother of twins, and a fashion icon. That none of these things preclude the other is what makes Tilda Swinton so utterly human, which in turn makes her so compelling to watch onscreen.

"I've always been interested in the transformations out of those set identities that society tends to lay on you."

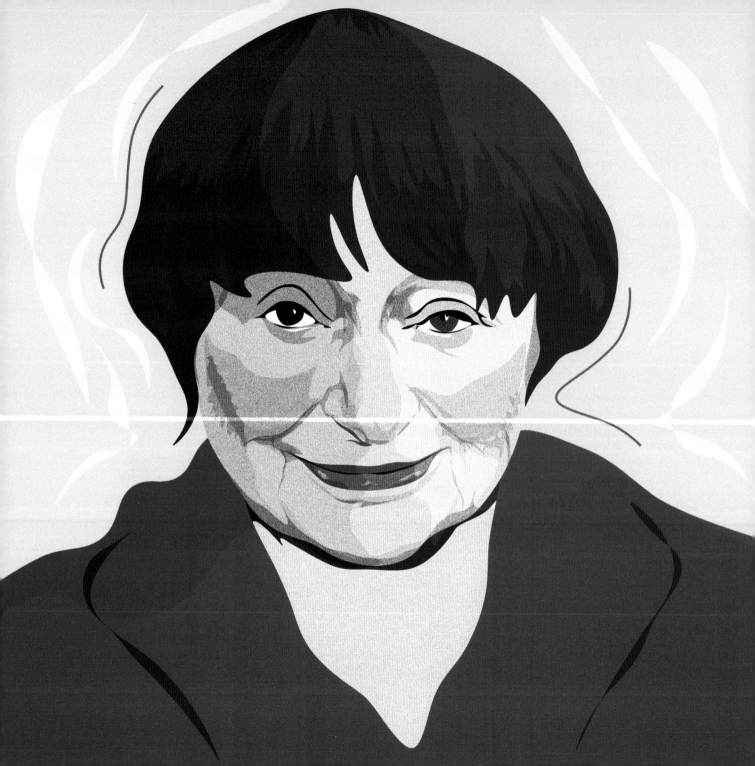

AGNÈS VARDA

"In all women there is something in revolt that is not expressed."

Agnès Varda was one of cinema's true visionaries. When she made her first film, *Le Pointe Courte*, she filmed on-location and used many non-professional actors at a time when stage sets and paid actors were the norm. By being at once a product of her time and an artistic outsider, she managed to create an entirely new language for film. *Le Pointe Courte* is considered a precursor to the French New Wave, and Agnès Varda is considered the movement's matriarch.

Agnès was born in Belgium in 1928 to a French mother, and a Greek father, though the family moved to France during World War II. Her route to filmmaking was at once organic and circuitous. She graduating from the Sorbonne with a bachelor's degree in psychology and literature, and then studied art history at the Louvre for a time. A growing interest in photography brought her to the École des Beaux-Arts; Agnès began seeking work as a photographer in the early 1950s. Her work framing and creating compositions for still photographs brought her to an interest in filmmaking. Agnès' cinematic style was ultimately a product of many influences—photography, of course, but her time spent studying literature and psychology informed her nascent interest in portraying her characters' emotions on screen.

Agnès married filmmaker Jacques Demy in 1962. Jacques adopted Agnès' daughter, Rosalie, whom she had in 1958 with actor Antoine Bourseiller, and the couple's son, Mathieu, was born in 1972. Early in Jacques and Agnès's marriage they spent time in Los Angeles. When the couple returned to France, Agnès felt she had been forgotten and bemoaned the trouble it took to get financing as a woman filmmaker. She and Jacques created their own production company Ciné-Tamaris, in 1977. Their careers continued apace until Jacques death in 1990. Agnès made a number of films in homage to Jacques after his death. Then, in 1999, she was given a digital camera for the first time, and she began working again from her own inspiration. In *Les Glaneurs et la Glaneuse* (*The Gleaners and I*) she examines how an itinerant group in France lives off of what other people throw away. Agnès draws parallels to the way that she creates her own art.

Agnès has been lauded for her groundbreaking and influential career, though much of the fanfare came late in her life. In 2017, she was the oldest director to be nominated for a competitive Oscar for *Faces, Places*; she was the first female director to win an honorary Academy Award for directing that same year. Agnès made films to share "a way of looking at people, a way of looking at life. If it can be shared, it means there is a common denominator. I think, in emotion, we have that. So even though I'm different or my experiences are different, they cross some middle knot."

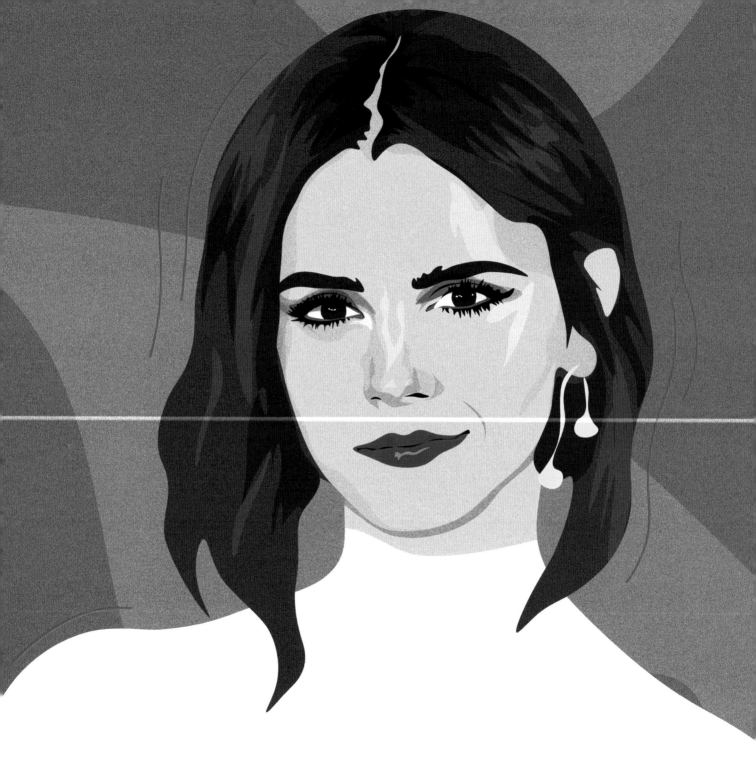

EMMA WATSON

There were many Harry Potter-themed signs at the Women's March in 2017, but one in particular stood out. *Without Hermione, Harry would have died in Book One.* For an entire generation of young readers, Hermione is their hero: smart, feisty, hardworking, and bossy enough to get shit done.

For better or for worse, Emma Watson is Hermione Granger. It's a fact she can't truly escape, though she's done enough in her post-Hermione career that, were it a less distinctive role, she'd be known for being a UN Women Goodwill Ambassador, or for having graduated with top grades from Brown University, for being an outspoken feminist, for a string of successful post-Hermione roles, or for her fashion and business acumen.

Emma grew up immersed in the reality of feminism—before she was old enough to formulate opinions, J.K. Rowling had given her a blueprint for equality among the sexes. Harry, Hermione, and Ron conquered many foes together over the course of the series; never once was Hermione considered less-than because she was a girl. More often than not, her clearheadedness saw the trio through whatever scrape they'd gotten themselves into in the first place. Emma, through that most formative role, learned how real and important the message of feminism—and the role of supportive men like Harry and Ron and Dumbledore and Hagrid—is in our world.

As she once said herself, "Acting is telling the truth under imaginary circumstances." There aren't circumstances much more imaginary than a wizarding school smack dab in the middle of modern-day Great Britain, and there isn't a truth more important to tell than the fight for good against evil.

Emma Watson helped launch the HeForShe campaign after being named UN Women Goodwill Ambassador in 2014. She gave a speech before the UN General Assembly in New York, in which she made the salient point that men needed to stand shoulder to shoulder with women in the fight for gender equality. When Emma referenced the speech that Hillary Clinton made at the at the Fourth Women's Conference in Beijing in 1995, she pointed out that many of the problems Hilary spoke of were still issues in 2014. More to the point, men made up only thirty percent of the audience in Beijing. For the message to get through, both genders need to be listening, and both genders need to take action. It was a call to arms.

In her role as UN Ambassador, Emma Watson has spoken at the World Economic Forum in Davos and traveled internationally to speak on behalf of the HeForShe campaign. She founded a feminist book club with Goodreads and continues to act in films. She has used her platform to raise awareness around sustainable fashion, to fight for education rights for young women all over the world, and to urge women to participate in politics at all levels. It turns out we don't need spells and magic to chase away the darkness—just earnest and hardworking young women who fight for change.

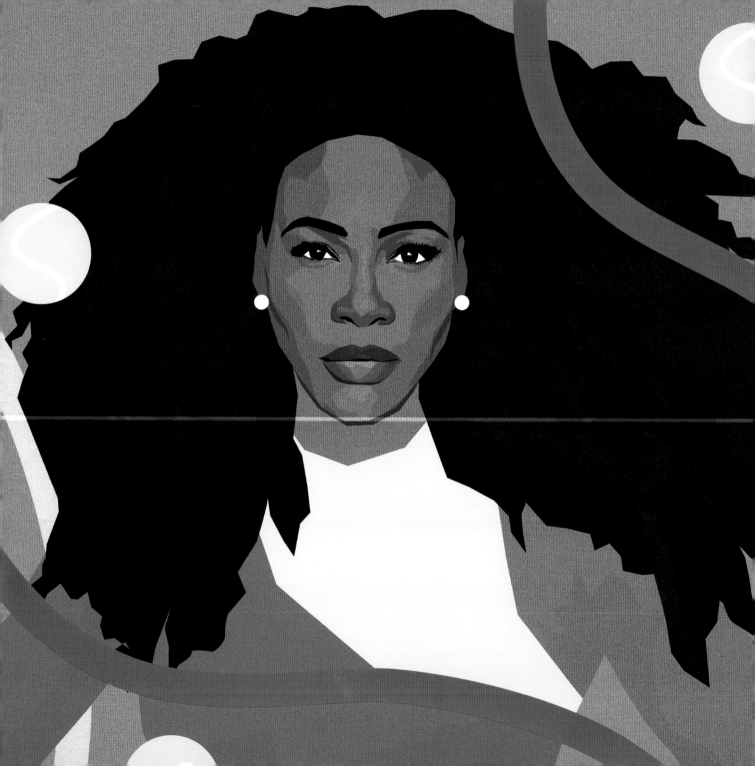

SERENA WILLIAMS

Serena Williams is so much more than a great tennis player. At a press conference at Wimbledon in 2019, a reporter asked what Serena thought of the idea that she should "stop fighting for equality and just focus on tennis." With her signature poker face intact, Serena responded, "Well the day I stop fighting for equality and for people that look like you and me would be the day I'm in my grave."

Serena sets a high bar for herself, in training, in competition, and in life. She claims the bar was set for her by her first coaches—her parents. Serena and her sister, Venus, first trained on hard courts in their Los Angeles neighborhood, with their parents taking turns drilling them. Story has it that when the girls heard gunshots—a common occurrence in Compton in the 1980s—they knew to lay down on the courts.

The family moved to Florida in support of the girls' tennis careers, though their parents kept them from the junior circuit. They trained instead of playing matches, a tactic that was unusual, though no one can deny its efficacy. Serena and Venus were able to develop in their own time, on their own terms, and the result changed the face of tennis forever. The sisters' dominance—two African American girls in a sport that saw little to no diversity until they came along—opened the door for many who came after them.

Serena's athleticism, her mental determination, and her drive to win are undeniable. But she's a bit of a Renaissance woman when it comes to interests outside of tennis. Serena speaks French and a smattering of other languages, she has worked in movies and on television, she has created clothing lines, she has made forays into venture capitalism, and she's an active and engaged philanthropic force.

She became a wife and mother in 2017, and while tennis is still her game, motherhood shifted her priorities. Where there was no question—tennis always came first—now there was her daughter to consider. Serena had a difficult delivery resulting in multiple surgeries, and she struggled with negative emotions in the months after giving birth. She doesn't take her health for granted, nor does she fail to recognize the gift of motherhood. "I still have to learn a balance of being there for her, and being there for me. I'm working on it. I never understood women before, when they put themselves in second or third place. And it's so easy to do. It's so easy to do."

Serena was seventeen years old when she won her first singles Grand Slam title. She has won Grand Slams for three decades running, and she has won the gold medal at the Olympics in singles and in doubles. Serena Williams is a champion, a wife, a mother, an activist, and a business woman. Greatest of All Time is a heavy mantle, but she manages to wear it lightly. "Even if my goals are outrageous, totally insane, I'd rather reach for the sky."

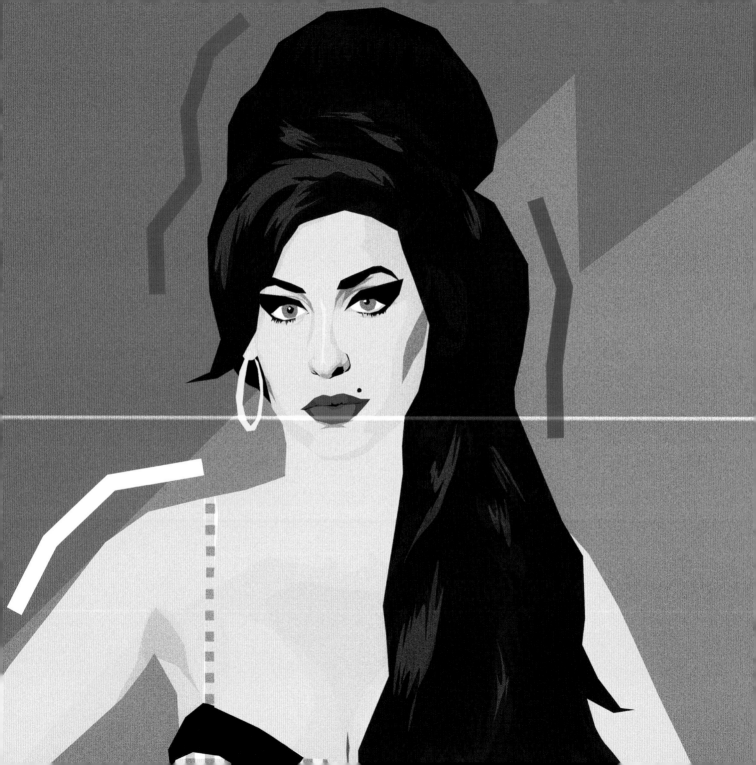

AMY WINEHOUSE

Amy Winehouse was a once-in-a-lifetime talent. Her voice, her vocal stylings, her influences, and her upbringing all contributed to creating a particular kind of magic. Amy came from a family that was serious about jazz—she sang standards around the house as a little girl, she joined the National Youth Jazz Orchestra as a teenager, and when Tony Bennet announced her name for best album at the Grammy Awards in 2007, Amy called to her father in the audience in disbelief. But it wasn't disbelief at the improbability of her success, or the speed of her ascent—"Dad," she called, "Tony Bennet."

When *Amy*, a documentary about her life, was released in 2015 it won both the Oscar and the BAFTA for best documentary. There is so much footage of her speaking in the film, it's as if her friends and relatives knew she would be famous one day, and set out to record her for posterity. Over and over in the film, Amy is asked about fame, about what her ambitions are, about what success would mean to her. And over and over, Amy says that she is scared of fame, she simply wants to write good music, and success would mean being left to do what she pleases.

Amy's parents divorced when she was nine and she claims the trauma was a springboard for rebellion. She drank and did drugs and blew off school, but it was also around this time that her maternal grandmother steered her toward classes at a performing arts school. She began singing jazz standards in clubs and writing her own music in high school. Heartache and relationships were her creative fodder; one of her first songs was "Stronger than Me" about her then-boyfriend who she bemoaned was too weak. When Amy met her future husband, Blake Fielder-Civil, a hard-living womanizer, she fell hard. Her multi-award winning album, *Back to Black*, was the result of Amy and Blake's first breakup.

That album changed everything for Amy. Blake came back to her, she toured America, and when she returned to England she was too famous for the anonymity she craved. Blake introduced her to hard drugs, and Amy spiraled into addiction. She grappled with addiction and alcoholism for the rest of her life, alternately binging and getting clean. Amy had been sober for a short while when she won five Grammy Awards for *Back to Black*, including Record of the Year, Best New Artist, and Best Song for "Rehab." Unfortunately, Amy's addictions had permanently compromised her health, and she died in 2011.

Amy recorded a duet of the jazz standard "Body and Soul" with Tony Bennet shortly before her death. Bennet said of her, "She was one of truest jazz singers I ever heard. To me she should be treated like Ella Fitzgerald, like Billie Holiday. She had the complete gift. If she had lived, I would have said, 'Slow down, you're too important.'"

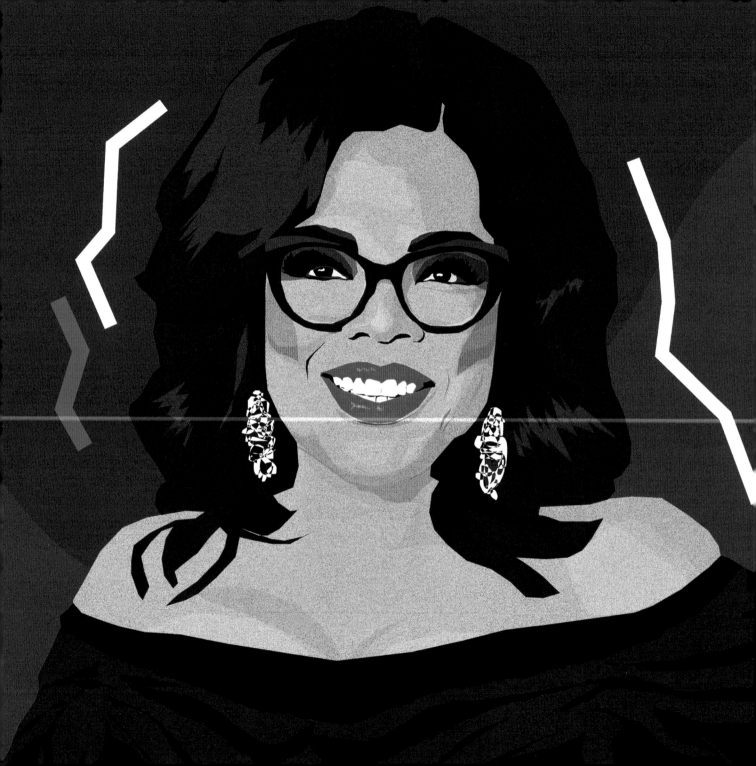

OPRAH WINFREY

Oprah Winfrey likes to be inspired. She likes to connect with people. Though she has said that, at this stage in her life, she will "only talk to who I want to talk to," there is no doubt that Oprah is going to keep talking as long as people will listen. And it seems people are going to keep listening. Probably because, unlike many who have the gift of gab, there is real substance to what Oprah has to say. Early on in her career, she decided that she wanted her television show to be a force for good. She shifted the focus of the *The Oprah Winfrey Show* from the kind of sensational stories that were common on daytime talk shows at the time to ones rooted in inspiring messages and positive change.

Her origin story is the stuff that superheroes are made of—her parents weren't there but she had a strict and loving grandmother; she was abused and ignored, but when she veered off course a father figure stepped in with love and a firm hand to get her back on the right path. By the time she was a teenager, she had begun her climb to greatness. She won prizes for dramatic recitation and public speaking in high school. She won a beauty pageant and was offered a radio job when she was seventeen. She won a full scholarship to Tennessee State University, where she majored in speech communications and performing arts. When her broadcast career began to show promise, she left college to work as a reporter and news anchor. When she was demoted to a morning talk show because the executives felt she was "too emotional" when she reported the news, Oprah found she was right where she belonged—talking with people, not to them. In short order, her morning show was beating out the competition and she was given her own daytime show. The rest, as they say, is history.

The Oprah Winfrey Show aired from 1986 to 2011. In 1988, Oprah received the International Radio and Television Society's Broadcaster of the Year Award. She was the youngest person ever to do so. She went on to start her own production company, found her own television network, start two magazines, found a school for girls in South Africa, and revitalize the publishing industry with her book club. Her philanthropy was recognized with the Jean Hersholt Humanitarian Award from the Academy of Motion Pictures, and there is an exhibition about her life at the Smithsonian's National Museum of African American History and Culture. In 2003, Forbes declared that she was the first African American woman to become a billionaire. The "Oprah Bill" was signed into law as the National Child Protection Act. *Life* magazine named her the most influential woman of her generation. And Oprah Winfrey was awarded the country's highest civilian honor, the Presidential Medal of Freedom.

With years of hard work, awards, and "firsts" under her belt, Oprah certainly deserves the opportunity to rest on her laurels. But that wouldn't be very Oprah of her, would it? Instead she has committed herself to helping others realize their own potential. She has made sure that important movies get made, that particular authors are read, and that the quiet but significant voices are heard. Because, in Oprah's own words, "the great reward and joy comes from being able to lift other people up."

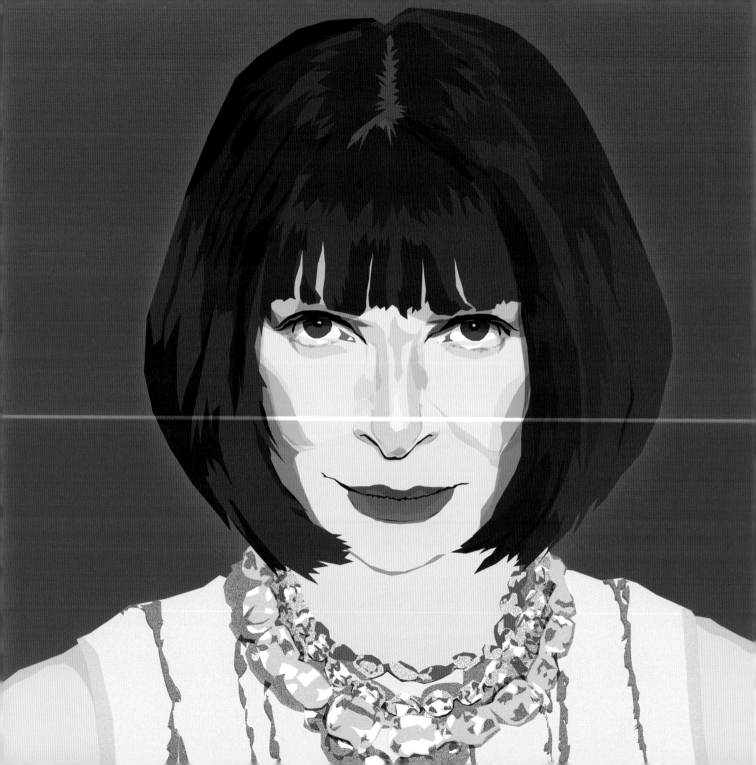

ANNA WINTOUR

Anna Wintour's first cover for *Vogue* caused quite a stir. The printer called to double check that there hadn't been a mistake. The woman on the cover was wearing jeans. Jeans and an haute couture Christian Lacroix jacket to be certain, but still: jeans . . . *on the cover*. Looking at the photo now, it's a study in casual elegance—street style before it was even a thing. But when Anna Wintour decided to put it on the cover in 1988, a time when close-ups and impeccable styling were the norm, she said it was simply because she "sensed the winds of change."

That has been Wintour's speciality when it comes to fashion—she always has her finger on the pulse. She took classes at a fashion school in London when she was young but quit because, in her words, "You either know fashion or you don't." Her father, Charles, was editor of *The Evening Standard*. He recognized Anna's talents early and got her a job at a fashionable boutique when she was fifteen. She led a glamorous life, dating older men and working her way up through the fashion and magazine ranks. She moved back and forth between London and New York (her mother, Eleanor, was American), working for British *Vogue* for two years before taking the helm at American *Vogue* in 1988.

From the start, Anna's perfectionist tendencies were legendary. The magazine's stature rose under her editorship, and Condé Nast, recognizing a good thing, named her the company's artistic director in 2013. *Vogue* and Anna Wintour are inextricably connected, and false rumors of her retirement send shock waves through the fashion world each time they surface. What would Anna be without *Vogue*? What would *Vogue* be without Anna?

Her influence extends far beyond the world of fashion. With the 2016 US presidential election, *Vogue* discovered the power of opposition. Through features and interviews, the magazine has raised the profile of female politicians in ways both subtle and overt. Wintour advised Hillary Clinton on her campaign and held one of President Obama's most successful fundraisers.

While the celebrities and fashionistas at the Met Gala tend to overshadow the fundraising impact of the event, the gala has raised close to $200 million since Wintour became chair. The Met's Costume Institute underwent renovations and was officially reopened in 2014 when Michelle Obama cut the ribbon on the rechristened Anna Wintour Costume Center. Wintour has also focused her fundraising efforts on AIDS, raising more than $10 million since 1990. She received the Dame Commander of the Order of the British Empire in 2017 for her contributions to British fashion.

Anna Wintour is one of the most powerful people in fashion, and her reputation precedes her wherever she goes. While it's easy to pick up snippets of her personality—she's an early riser, she loves tennis, she has a dry wit—she is, ultimately, as inscrutable as a public figure can be. That seems to be just the way Anna Wintour likes it.

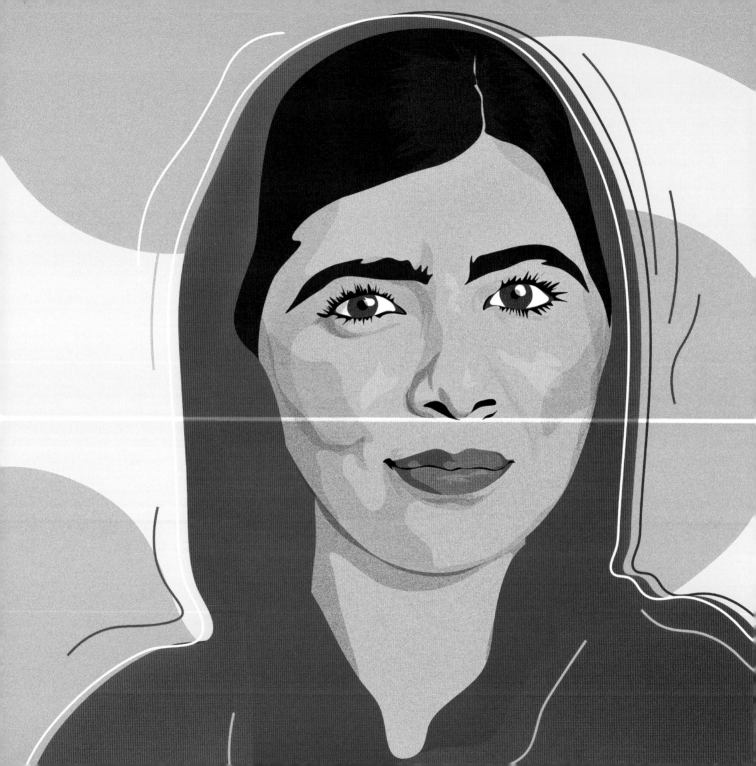

MALALA YOUSAFZAI

On October 12, 2012, a Taliban gunman boarded a bus and shot Malala Yousafzai three times, shattering the left side of her skull. She was sent to a hospital in Birmingham, England, where she underwent a surgery that entailed replacing a part of her skull with titanium. It's easy to draw an analogy—as her new titanium skull is stronger than the bone that was there before the assassination attempt, so is Malala stronger and more dangerous to the Taliban for having survived it.

When Malala was shot, she was a few months shy of her fifteenth birthday. She had been an outspoken critic of the Taliban's ban on girls' education; she had written a blog for the BBC Urdu under a pseudonym starting at age twelve, and she launched on ongoing campaign for girls' access to education in Pakistan, giving public speeches and granting press interviews. Her exposure only grew after the shooting, and her message gained a broader audience. The terrorists' attempt to silence their opponent had backfired. Now the whole world was listening to a little girl from Pakistan.

Malala was raised in Swat Valley and has said that though her father was an educator, she didn't realize what she had lost until schools were closed to girls. "It's human nature," she said, that "we don't learn the importance of anything until it is snatched from our hands." When she had recovered from the shooting, Malala and her father established Malala Fund, a charity that promotes and supports girls' access to education across the world. Malala finished high school and went on to study at Oxford University in England.

Malala was seventeen years old when she received the Nobel Peace Prize in 2014. She was the youngest person to receive the prize, and the first Pakistani. She joked, in her acceptance speech, about being the only Nobel laureate who still fought with her little brothers. Her message is one of inspiration and hope, and her activism advances the causes that mean so much to her. She attends school, and she travels around the world telling her story and campaigning for change. "Why is it that countries which we call 'strong' are so powerful in creating wars but are so weak in bringing peace?"

Malala was born in 1997. Already in her short life she has spoken before the UN assembly; written books for adults and children; been the subject of a documentary and a biopic; and advanced the causes of girls' education, refugees, and peace through her foundations and activism. She has been compared to her heroes and fellow activists Nelson Mandela, Mother Teresa, and Martin Luther King, Jr., inspirational figures who dedicated their entire lives to their causes. Malala's strength and passion will serve her for many years to come, and the world is certainly a better place for her work.

Adele

Hiatt, Brian. "Adele: Inside Her Private Life and Her Triumphant Return." *Rolling Stone* magazine website. November 3, 2015. https://www.rollingstone.com/music/music-features/adele-inside-her-private-life-and-triumphant-return-37131/

NPR staff. "'You Can't Prepare Yourself': A Conversation with Adele." National Public Radio website. November 24, 2015. https://www.npr.org/2015/11/24/457252109/you-cant-prepare-yourself-a-conversation-with-adele

Robinson, Lisa. "Adele, Queen of Hearts." *Vanity Fair* magazine website. October 31, 2016. https://www.vanityfair.com/culture/2016/10/adele-cover-story

Van Meter, Jonathan. "Adele: One and Only." *Vogue* magazine website. February 12, 2012. https://www.vogue.com/article/adele-one-and-only

Chimamanda Ngozi Adichie

Adichie, Chimamanda Ngozi. "We Should All Be Feminists" (April 2017) and "The Danger of a Single Story." (October 2009). TED Talks. https://www.ted.com/talks/chimamanda_ngozi_adichie_we_should_all_be_feminists https://www.ted.com/talks/chimamanda_adichie_the_danger_of_a_single_story

Chimamanda Adichie website. Accessed August 2019. https://www.chimamanda.com/about-chimamanda/

"Chimamanda Adichie." The MacArthur Foundation website. Accessed August 2018. https://www.macfound.org/fellows/69/

MacFarquhar, Larissa. "Chimamanda Ngozi Adichie Comes to Terms with Global Fame." The *New Yorker* magazine website. May 28, 2018. https://www.newyorker.com/magazine/2018/06/04/chimamanda-ngozi-adichie-comes-to-terms-with-global-fame

Trevor Noah interviews Chimamanda Ngozi Adichie. *The Daily Show.* Comedy Central. June 6, 2018. https://www.cc.com/video-clips/01xa9a/the-daily-show-with-trevor-noah-chimamanda-ngozi-adichie----dear-ijeawele--and-raising-a-child-to-be-a-feminist---extended-interview

Maya Angelou

"A Phenomenal Woman." Introduction by Edwidge Danticat. Moderated by Murray Fisher. *Playboy* magazine website. February 21, 2019. https://www.playboy.com/read/a-phenomenal-woman

Angelou, Maya. "Why I Moved Back to the South." *Ebony* magazine. February 1982. https://books.google.com/books?id=deYZsW0DlSIC&pg=PA130&lpg=PA130&dq=ebony+1982+maya+angelou&source=bl&ots=j7rNG6rqaC&sig=1eI3e-lIbEmIKKoqjFwiHP8tdK4&hl=en&sa=X&ei=Bv5DT+rdGdKztwfY0em6BQ#v=onepage&q&f=false

Coburn Whack, Rita, and Bob Hercules, directors. "Maya Angelou: And Still I Rise." *American Masters* on PBS. October 14, 2016.

Moore, Lucinda. "Growing Up Maya Angelou." *Smithsonian* magazine website. April 2003. https://www.smithsonianmag.com/arts-culture/growing-up-maya-angelou-79582387/

"Remembering Dr. Maya Angelou." Wake Forest University website. Accessed August 2019. https://mayaangelou.wfu.edu/

Ruth Asawa

Johnson, Mark, and Paul Karlstrom. Oral history transcript of interview with Ruth Asawa and Albert Lanier. Smithsonian Archives of American Art website. Accessed August 2019. https://www.aaa.si.edu/collections/interviews/oral-history-interview-ruth-asawa-and-albert-lanier-12222#transcript

Martin, Douglas. "Ruth Asawa, an Artist Who Wove Wire, Dies at 87." The *New York Times* website. August 17, 2013. https://www.nytimes.com/2013/08/18/arts/design/ruth-asawa-an-artist-who-wove-wire-dies-at-87.html

Ruth Asawa website. Accessed August 2019. https://ruthasawa.com/

"The Sculpture of Ruth Asawa: Contours in the Air." The De Young Museum website. Accessed August 2019. https://deyoung.famsf.org/deyoung/exhibitions/sculpture-ruth-asawa-contours-air

Beyoncé

Beyoncé website. Accessed August 2019. https://www.beyonce.com

CBS interviews Beyoncé. February 2016. https://www.youtube.com/watch?v=L5wr7fBa27k

Macpherson, Alec. "Beyoncé's Formation review - a rallying cry that couldn't be more timely." The *Guardian* website. February 8, 2016. https://www.theguardian.com/music/musicblog/2016/feb/08/beyonce-formation-review-super-bowl-rallying-cry-black-consciousness

"Beyoncé in Her Own Words: Her Life, Her Body, Her Heritage." *Vogue* magazine website. August 6, 2018. https://www.vogue.com/article/beyonce-september-issue-2018

Cher

Aguirre, Abby. "Cher on Love, Loss, Failure, and Success Beyond Imagination." *Elle* magazine website. November 19, 2018. https://www.elle.com/culture/celebrities/a25222980/cher-december-2018/

Bruni, Frank. "An Ageless Diva of a Certain Age." The *New York Times* website. November 18, 2010. https://www.nytimes.com/2010/11/21/movies/21cher.html

Fisher, Lauren Alexis. "Bob Mackie Didn't Know How to Dress Cher When They First Met. Now, He's Part of Her Fashion Legacy." *Harper's Bazaar* magazine website. March 8, 2019. https://www.harpersbazaar.com/fashion/designers/a26029031/bob-mackie-cher-show-interview/

Jenna Bush Hager interviews Cher and Bob Mackie. The *Today Show* website. April 15, 2019. https://www.today.com/video/see-cher-s-extended-interview-with-jenna-bush-hager-1493595715519

Sheffield, Rob. "We Got Her, Babe: Cher Stands Alone." *Rolling Stone* magazine website. February 28, 2019. https://www.rollingstone.com/music/music-features/cher-stands-alone-800801/

Hillary Clinton

"Hillary Clinton Fast Facts." CNN online. Accessed August 2019. https://www.cnn.com/2012/12/20/us/hillary-clinton---fast-facts/index.html

"Hillary Rodham Clinton." The online archives of the Obama White House. Accessed August 2019. https://obamawhitehouse.archives.gov/1600/first-ladies/hillaryclinton

Leibovich, Mark. "In Turmoil of '68, Clinton Found a New Voice." The *New York Times* website. September 5, 2007. https://www.nytimes.com/2007/09/05/us/politics/05clinton.html

The Office of Hillary Rodham Clinton website. Accessed August 2019. https://www.hillaryclinton.com

"What Is Hillary's Greatest Accomplishment?" *Politico Magazine.* September 17, 2015. https://www.politico.com/magazine/story/2015/09/carly-fiorina-debate-hillary-clintons-greatest-accomplishment-213157

Amal Clooney

"Amal Clooney." Doughty Street Chambers website. Accessed August 2019. https://www.doughtystreet.co.uk/barristers/amal-clooney

"Amal Clooney appointed Foreign Office special envoy." BBC news website. April 5, 2019. https://www.bbc.com/news/uk-47825327

Bowcott, Owen. "Human rights judges reject final appeal of Troubles 'hooded men.'" The *Guardian* website. September 11, 2018. https://www.theguardian.com/uk-news/2018/sep/11/echr-judges-reject-final-appeal-in-troubles-hooded-men-case-british-army-detainees-torture

Cynthia McFadden in conversation with Amal Clooney. NBC News website. September 19, 2016. https://www.nbcnews.com/news/world/amal-clooney-takes-isis-clear-case-genocide-yazidis-n649126

Misty Copeland

Copeland, Grace Misty, and Charisse Jones. *Life in Motion: An Unlikely Ballerina.* Misty Copeland, 2014.

Jefferson, J'na. "Style En Pointe." *Vibe* magazine website. February 28, 2019. https://www.vibe.com/2019/02/misty-copeland-under-armour-feature

"Misty Copeland." American Ballet Theater website. Accessed August 2019. https://www.abt.org/people/misty-copeland

The Official Website of Misty Copeland. Accessed August 2019. https://mistycopeland.com/

Wareham, Julie Wilson. "Misty On Pointe." *Essence* magazine website. August 9, 2015. https://www.essence.com/celebrity/misty-copeland-essence-september-cover/

Sofia Coppola

Guy Lodge interviews Sofia Coppola. The *Guardian* website. July 2, 2017. https://www.theguardian.com/film/2017/jul/02/sofia-coppola-beguiled-i-never-felt-i-had-to-fit-into-the-majority-view-interview

Hoberman, J. "Why Hasn't Sofia Coppola Gotten the Respect an Auteur Deserves?" The *New York Times* website. February 20, 2019. https://www.nytimes.com/2019/02/20/movies/sofia-coppola-director-writer.html

Mitchell, Wendy. "Sofia Coppola Talks About 'Lost in Translation,' Her Love Story That's Not 'Nerdy.'" IndieWire website. February 4, 2004. https://www.indiewire.com/2004/02/sofia-coppola-talks-about-lost-in-translation-her-love-story-thats-not-nerdy-79158/

Prince. Richard. Interview with Sofia Coppola. *Interview* magazine website. June 14, 2013. https://www.interviewmagazine.com/film/sofia-coppola

Yepes, Julia. "The Quiet Storms of Sofia Coppola." *Interview* magazine website. June 23, 2017. https://www.interviewmagazine.com/film/sofia-coppola-the-beguiled

Laverne Cox

A Trans History: Time Marches Forward and So Do We. ACLU. August 10, 2017.

Laverne Cox Presents: The T Word. MTV. October 17, 2014.

Steinmetz, Katy. "Laverne Cox Talks to *Time* About the Transgender Movement." *Time* magazine website. May 29, 2014. https://time.com/132769/transgender-orange-is-the-new-black-laverne-cox-interview/

Steinmetz, Katy. "The Transgender Tipping Point." *Time* magazine website. May 29, 2014. https://time.com/135480/transgender-tipping-point/

Taluson, Meredith. "Trans Is Beautiful: Laverne Cox on the Work of Self-Love." *Self* magazine website. October 17, 2018. https://www.self.com/story/laverne-cox

Ellen DeGeneres

Aswell, Sarah. "How Ellen Degeneres Stayed 'Relatable' While Making $294,000 a Minute." *Forbes* magazine website. December 24, 2018. https://www.forbes.com/sites/sarahaswell/2018/12/24/how-ellen-degeneres-stayed-relatable-while-making-294000-a-minute/#60d705b45086

David Letterman and Ellen DeGeneres in conversation. *My Next Guest Needs No Introduction.* Netflix. May, 2019.

Oprah Winfrey in conversation with Ellen Degeneres. The *Oprah Winfrey Show.* April, 1997.

Rhodes, Joe. "Carson's Code." The *New York Times* website. January 30, 2005. https://www.nytimes.com/2005/01/30/arts/television/carsons-code.html

Joan Didion

Dunne, Griffin, director. *The Center Will Not Hold.* Netflix. October 27, 2017.

Hilton Als interviews Joan Didion. "Joan Didion, The Art of Nonfiction No. 1." The *Paris Review* website. Spring 2006. https://www.theparisreview.org/interviews/5601/joan-didion-the-art-of-nonfiction-no-1-joan-didion

Joan Didion biography. Academy of Achievement website. Accessed August 2019. https://www.achievement.org/achiever/joan-didion/

Ava DuVernay

Amy Goodman interviews Ava DuVernay. "*Selma* Director Ava DuVernay on Hollywood's Lack of Diversity, Oscar Snub and #OscarsSoWhite Hashtag." Democracy Now website. January 27, 2015. https://www.democracynow.org/2015/1/27/selma_director_ava_duvernay_on_hollywoods

Buchanan, Kyle. "Ava DuVernay: Real People Aren't Seeing Most Movies." The *New York Times* website. June 20, 2019. https://www.nytimes.com/2019/06/20/movies/ava-duvernay-movies.html

Greene, Adrienne. "Ava DuVernay on *Queen Sugar* and Her Hollywood Journey." The *Atlantic* magazine website. August 3, 2017. https://www.theatlantic.com/entertainment/archive/2017/08/ava-duvernay-queen-sugar-midseason-finale/535710/

Obenson, Tambay. "Ava DuVernay's ARRAY: Opening a Theater, With Sundance Institute-Sized Ambitions." IndieWire website. April 15, 2019. https://www.indiewire.com/2019/04/ava-duvernay-array-affrm-burial-of-kojo-1202053860/

Terry Gross interviews Ava DuVernay. "Ava DuVernay Focuses on the Central Park Five's Perspective: 'Now People Know.'" *Fresh Air* on National Public Radio website. June 19, 2019. https://www.npr.org/2019/06/19/733722341/ava-duvernay-focuses-on-the-central-park-5s-perspective-now-people-know

Aretha Franklin

"Aretha Franklin." The Rock and Roll Hall of Fame website. Accessed August 2019. https://www.rockhall.com/inductees/aretha-franklin

Blake, John. "Before Aretha Franklin was a superstar, her father shone on a different stage." CNN online. August 30, 2018. https://www.cnn.com/2018/08/30/us/aretha-franklin-father/index.html

Elliot, Alan, director. *Amazing Grace*. Aretha Franklin. Neon. 2019. 89 minutes.

Gilmore, Mikal. "The Queen Aretha Franklin 1942-2018." *Rolling Stone* magazine website. September 27, 2018. https://www.rollingstone.com/music/music-features/aretha-franklin-tribute-cover-story-queen-729053/

Lang, Cady. "Aretha Franklin Wasn't Just a Music Legend. She Also Raised Her Voice for Civil Rights." *Time* magazine website. August 16, 2018. https://time.com/5369587/aretha-franklin-civil-rights/

Lady Gaga

D'Souza, Nandini. "Going Gaga for Lady Gaga." *W* magazine website. October 2007. https://web.archive.org/web/20120513084651/http://www.wmagazine.com/celebrities/2007/10/lady_gaga

Grigoriadis, Vanessa. "Growing Up Gaga." *New York* magazine website. March 28, 2010. https://nymag.com/arts/popmusic/features/65127/index.html

Hobart, Erika. "Lady Gaga: Some Like It Pop." *Seattle Weekly* website. November 18, 2008. https://www.seattleweekly.com/music/lady-gaga-some-like-it-pop/

Moukarbel, Chris. *Gaga: Five Foot Two*. Netflix. September 22, 2017. 100 minutes.

Van Meter, Jonathan. "Lady Gaga Opens Up About *A Star Is Born*, Me Too, and a Decade in Pop." *Vogue* magazine website. September 10, 2018. https://www.vogue.com/article/lady-gaga-vogue-cover-october-2018-issue

Ruth Bader Ginsburg

Cohen, Julie, and Betsy West, directors. *RBG*. Magnolia Pictures, 2018. 98 minutes.

"Current Members." The Supreme Court of the United States website. Accessed August 2019. https://www.supremecourt.gov/about/biographies.aspx

De Hart, Jane Sherron. *Ruth Bader Ginsburg: A Life*. New York: Knopf, 2016.

Ruth Bader Ginsburg biography. Academy of Achievement website. Accessed August 2019. https://www.achievement.org/achiever/ruth-bader-ginsburg/

Jane Goodall

Peterson, Dale. *Jane Goodall: The Woman Who Redefined Man*. Houghton Mifflin, 2006.

The Jane Goodall Institute for Wildlife Research and Conservation website. Accessed August 2019. https://www.janegoodall.org/

Zaha Hadid

"Biography of Zaha Hadid." The Art Story website. Accessed August 2019. https://www.theartstory.org/artist/hadid-zaha/life-and-legacy/

Kimmelman, Michael. "Zaha Hadid, Groundbreaking Architect, Dies at 65." The *New York Times* website. March 31, 2016. https://www.nytimes.com/2016/04/01/arts/design/zaha-hadid-architect-dies.html

Polier, Alexandra. "Architecture in Baghdad." *Dwell* magazine website. February 29, 2012. https://www.dwell.com/article/architecture-in-baghdad-603e33ad

Zaha Hadid Architects website. Accessed August 2019. https://www.zaha-hadid.com/

"Zaha Hadid." The Pritzker Architecture Prize website. Accessed August 2019. https://www.pritzkerprize.com/laureates/2004

Audrey Hepburn

"Audrey Hepburn." Unicef website. Accessed August 2019. https://www.unicef.org/people/people_audrey_hepburn.html

Avery, Daniel, and H. Alan Scott. "The Singular Glamour of Audrey Hepburn." *Newsweek* website. May 4, 2019. https://www.newsweek.com/audrey-hepburn-birthday-style-1407352

Ferrer, Sean Hepburn. *Audrey Hepburn: An Elegant Sprit*. Atria Books, 2003.

Maychick, Diana. *Audrey Hepburn: An Intimate Portrait*. Carol Publshing Group, 1993.

Spoto, Donald. *Enchanted: The Life of Audrey Hepburn*. Harmony Books, 2006.

Whitney Houston

Associated Press interview with Clive Davis. Accessed August 2019. https://www.youtube.com/watch?v=weNZFgpLidE

DeCurtis, Anthony. "Whitney Houston: Down and Dirty." *Rolling Stone* website. June 10, 1993. https://www.classicwhitney.com/interview/rollingstone_1993.htm

Schulman, Michael. "The Complexities of Whitney Houston in 'Whitney.'" The *New Yorker* website. July 7, 2018. https://www.newyorker.com/culture/culture-desk/the-complexities-of-whitney-houston-in-whitney

Seal, Mark. "The Devils in the Diva." *Vanity Fair* magazine website. May 8, 2012. https://www.vanityfair.com/hollywood/2012/06/whitney-houston-death-bathtub-drugs-rehab

Grace Jones

Andy Warhol and André Leon Talley interview Grace Jones. *Interview* magazine website. July 16, 2014. https://www.interviewmagazine.com/music/new-again-grace-jones

Christian Amanpour interviews Grace Jones. CNN online. Accessed August 2019. https://www.cnn.com/videos/world/2017/11/02/intv-amanpour-grace-jones.cnn

Muller, Marissa. "Grace Jones on Turning Her Experience with Abuse into a Lifetime of Being Fierce: 'I Pack a Good Wallop.'" *W* magazine online. April 10, 2018. https://www.wmagazine.com/story/grace-jones-documentary-interview

Sawyer, Miranda. "State of Grace." The *Guardian* online. October 10, 2008. https://www.theguardian.com/music/2008/oct/12/grace-jones-hurricane

Tobias, Scott. "A Diva Deconstructed in 'Grace Jones: Bloodlight and Bami.'" National Public Radio website. April 12, 2018. https://www.npr.org/2018/04/12/601106353/a-diva-deconstructed-in-grace-jones-bloodlight-and-bami

Frida Kahlo

Farago, Jason. "Frida Kahlo's Home Is Still Unlocking Secrets, 50 Years Later." The *New York Times* website. February 7, 2019. https://www.nytimes.com/2019/02/07/arts/design/frida-kahlo-review-brooklyn-museum.html

"Frida Kahlo." National Museum of Women in the Arts website. Accessed August 2019. https://nmwa.org

Kleinman, Rebecca. "Frida Kahlo Was a Painter, a Brand Builder, a Survivor. And So Much More." The *New York Times* website. January 31, 2019. https://www.nytimes.com/2019/01/31/arts/design/frida-kahlo-brooklyn-museum.html

The website of the Frida Kahlo Foundation. Accessed August 2019. https://www.frida-kahlo-foundation.org/

Mindy Kaling

Dravid, Supriya. "The Magic of Mindy." *Elle* magazine website. May 4, 2018. https://elle.in/article/mindy-kaling-cover/

Kaling, Mindy. "How I Used What Sucked About High School to Come Out on Top." *Seventeen* magazine website. August 11, 2015. https://www.seventeen.com/celebrity/a32999/mindy-kaling-high-school-advice/

Marchese, David. "Mindy Kaling on Not Being the Long-Suffering Indian Woman." The *New York Times* website. June 10, 2019. https://www.nytimes.com/interactive/2019/06/10/magazine/mindy-kaling-late-night-diversity-comedy.html

Radloff, Jessica. "Mindy Kaling: 'You Have to Make Your Imprint and Get Your Coin.'" *Glamour* magazine website. June 4, 2019. https://www.glamour.com/story/mindy-kaling-june-2019-cover-story

Sittenfeld, Curtis. "A Long Day at 'The Office' With Mindy Kaling." The *New York Times* magazine website. September 23, 2011. https://www.nytimes.com/2011/09/25/magazine/a-long-day-at-the-office-with-mindy-kaling.html

Rei Kawakubo

Foley, Bridget. "Rei Kawakubo Speaks." *Women's Wear Daily* website. December 20, 2013. https://wwd.com/fashion-news/fashion-features/rei-kawakubo-speaks-7322544/

Frankel, Susannah. "A Rare Conversation with Rei Kawakubo." *AnOther* magazine website. February 13, 2019. https://www.anothermag.com/fashion-beauty/11486/cover-story-rare-interview-rei-kawakubo-comme-des-garcons-fashion-designer-2019

"Rei Kawakubo." *Interview* magazine website. October 13, 2015. https://www.interviewmagazine.com/fashion/rei-kawakubo-1

Thurman, Judith. "The Misfit." The *New Yorker* magazine website. July 21, 2014. https://www.newyorker.com/magazine/2005/07/04/the-misfit-3

Yaeger, Lynn. "On the Eve of the Comme des Garçons Retrospective, the Notoriously Reclusive Rei Kawakubo Speaks Out." *Vogue* magazine website. April 13, 2017. https://www.vogue.com/article/rei-kawakubo-interview-comme-des-garcons-2017-met-museum-costume-exhibit

Grace Kelly

Harvey, Evelyn. "The Key to Kelly." *Collier's Weekly.* June 24, 1955. https://www.unz.com/print/Colliers-1955jun24-00036/Contents/

Jacobs, Laura. "Grace Kelly's Forever Look." *Vanity Fair* magazine website. March 30, 2010. https://www.vanityfair.com/news/2010/05/grace-kelly-201005

Spoto, Donald. *High Society: The Life of Grace Kelly.* Harmony, 2009.

"The 28th Academy Awards Memorable Moments." The Academy Awards website. Accessed August 2019. https://www.oscars.org/oscars/ceremonies/1956/memorable-moment

"1982: Hollywood Princess Dead." BBC online. Accessed August 2019. http://news.bbc.co.uk/onthisday/hi/dates/stories/september/14/newsid_2516000/2516601.stm

Yayoi Kusama

Blair, Elizabeth. "'Priestess of Polka Dots' Yayoi Kusama Gives Gallerygoers a Taste of Infinity." National Public Radio website. March 1, 2017. https://www.npr.org/2017/03/01/516659735/priestess-of-polka-dots-yayoi-kusama-gives-gallerygoers-a-taste-of-infinity

Kusama, Yayoi. *Infinity Net: The Autobiography of Yayoi Kusama.* Translated by Ralph McCarthy. Chicago: University of Chicago Press, Translation Edition 2012.

Munroe, Alexandra. "Yayoi Kusama at 90: How the 'undiscovered genius' became an international sensation." CNN online. March 22, 2019. https://www.cnn.com/style/article/yayoi-kusama-artist/index.html

Yayoi Kusama website. Accessed August 2019. https://yayoi-kusama.jp/e/biography/index.html

"Yayoi Kusama Interview: Earth Is a Polka Dot." Interview by Christian Lund. Louisiana Museum of Modern Art, London, February 2011. https://www.youtube.com/watch?v=21NrNdse7nI

Jennifer Lopez

Chocano, Carina. "Jennifer Lopez Is (Still) on Top of the World." *Harper's Bazaar* magazine website. January 9, 2019. https://www.harpersbazaar.com/culture/features/a25725553/jennifer-lopez-second-act-interview-2019/

La Porte, Nicole. "J. Lo: The Sequel." The *New York Times* website. May 13, 2001. https://www.nytimes.com/2011/05/15/fashion/jennifer-lopez-the-peoples-pop-star.html

Ryzik, Melena. "Jennifer Lopez on Her Power Bossness, 'Second Act' and A-Rod." The *New York Times* website. October 31, 2018. https://www.nytimes.com/2018/10/31/movies/jennifer-lopez-second-act.html

Tyrangiel, Josh. "Jennifer Lopez." *Time* magazine website. August 13, 2005. https://web.archive.org/web/20090301064251/http://www.time.com/time/nation/article/0%2C8599%2C1093638%2C00.html

Madonna

David Blaine interviews Madonna. *Interview* magazine website. November 26, 2014. https://www.interviewmagazine.com/music/madonna-1

Grigoriadis, Vanessa. "Madonna at Sixty." The *New York Times* website. June 5, 2019. https://www.nytimes.com/2019/06/05/magazine/madonna-madame-x.html

Marilyn Monroe

Meryman, Richard. Edited version of "Last Talk with a Lonely Girl: Marilyn Monroe." The *Guardian* online. Accessed August 2019. https://www.theguardian.com/theguardian/2007/sep/14/greatinterviews

Lupita Nyong'o

Framke, Caroline. "*Black Panther's* Michael B. Jordan and Lupita Nyong'o on Wakandan Women and 'Owning Your Identity.'" *Variety* magazine website. January 11, 2019. https://variety.com/2019/film/news/black-panther-lupita-nyongo-michael-b-jordan-interview-1203105502/

Gardner, Elysa. "From Kenya (via Yale) with Style: Film's Lupita Nyong'o." *USA Today* website. February 8, 2014. https://www.usatoday.com/story/life/movies/2014/02/08/oscar-nominee-lupita-nyongo-discusses-her-amazing-journey/5080445/

Hunt, Kenya. "Lupita Nyong'o: The Power Awakens." *Elle* magazine website. March 12, 2015. https://www.elle.com/uk/fashion/news/a28579/lupita-nyongo-january-2015-cover-star/

Morris, Alex. "Lupita Nyong'o, From Unknown to 'It' Girl in Less Than a Year." The Cut website. February 9, 2014. https://www.thecut.com/2014/02/lupita-nyongo-new-fashion-it-girl.html

Okeowo, Alexis. "How Lupita Nyong'o Transformed Herself Into Hollywood's Newest Superhero." *Vogue* magazine website. December 11, 2017. https://www.vogue.com/article/lupita-nyongo-black-panther-vogue-january-2018-issue

Michelle Obama

Anderson, Bruce. "Michelle Obama Shares 3 Ideas to Help Companies Recruit Diverse Talent." LinkedIn website. January 8, 2019. https://business.linkedin.com/talent-solutions/blog/diversity/2019/michelle-obama-shares-3-ideas-to-help-companies-recruit-diverse-talent

"Michelle Obama." The White House website. Accessed August 2019. https://www.whitehouse.gov/about-the-white-house/first-ladies/michelle-obama/

Obama, Michelle. *Becoming.* New York: Crown Publishing Group, 2018.

Public Allies website. Accessed August 2019. https://publicallies.org/about-us/

Alexandria Ocasio Cortez

Alter, Charlotte. "'Change Is Closer Than We Think.' Inside Alexandria Ocasio-Cortez's Unlikely Rise." *Time* magazine website. March 21, 2019. https://time.com/longform/alexandria-ocasio-cortez-profile/

Morris, Alexander. "Alexandria Ocasio-Cortez Wants the Country to Think Big." *Rolling Stone* magazine website. February 27, 2019. https://www.rollingstone.com/politics/politics-features/alexandria-ocasio-cortez-congress-interview-797214/

New Yorker Radio Hour. David Remnick interviews Alexandria Ocasio-Cortez. WNYC Studios and the *New Yorker.* July 10, 2019. https://www.newyorker.com/news/the-new-yorker-interview/alexandria-ocasio-cortez-on-the-2020-presidential-race-and-trumps-crisis-at-the-border

Tracy, Abigail. "'I Felt Like I Was Being Physically Ripped Apart': Alexandria Ocasio-Cortez Opens Up About Her New Fame, Trump, and Life in the Bubble." *Vanity Fair* magazine website. March 11, 2019. https://www.vanityfair.com/news/2019/03/alexandria-ocasio-cortez-interview

United States House of Representatives website. Accessed August 2019. https://ocasio-cortez.house.gov/

Queen Elizabeth II

Bedell Smith, Sally. *Elizabeth the Queen: The Life of a Modern Monarch.* New York: Random House, 2012.

"Her Majesty The Queen." The British Royal Family website. Accessed August 2019. https://www.royal.uk/her-majesty-the-queen

Rosa Parks

"NAACP History: Rosa Parks." National Association for the Advancement of Colored People website. Accessed August 2019. https://www.naacp.org/naacp-history-rosa-parks/

Norwood, Arlisha. "Rosa Parks." National Women's History Museum website. Accessed August 2019. https://www.womenshistory.org/education-resources/biographies/rosa-parks

Rosa Parks biography. Academy of Achievement website. Accessed August 2019. https://www.achievement.org/achiever/rosa-parks/

Rosa Parks interview. 1995. https://www.youtube.com/watch?v=bqiQqM9nQ0U

Dolly Parton

Dolly Parton website. Accessed August 2019. https://dollyparton.com/

Imagination Library website. Accessed August 2019. https://imaginationlibrary.com/

Parton, Dolly. *Dolly: My Life and Other Unfinished Business.* New York: Harper Collins, 1995

Price, Deborah Evans. "Dolly Parton: Songwriting Is Her Priority." American Songwriter website. March 1, 1990. https://americansongwriter.com/1990/03/dolly-parton-songwriting-is-her-priority/

Rihanna

Alston, Trey. "Rihanna Has Work Work Worked Her Way to a $600 Million Empire." MTV online. June 4, 2019. https://www.mtv.com/news/3126260/rihanna-richest-female-musician-600-million/

Nnadi, Chioma. "Rihanna on Body Image, Turning 30, and Staying Real—No Matter What." *Vogue* magazine website. May 3, 2018. https://www.vogue.com/article/rihanna-vogue-cover-june-issue-2018

Patterson, Sylvia. "Singing in the Rain." The *Guardian* online. August 25, 2007. https://www.theguardian.com/music/2007/aug/26/popandrock

Paulson, Sarah. "Meet Rihanna, the Shy Gal." *Interview* magazine website. June 10, 2019. https://www.interviewmagazine.com/music/meet-rihanna-the-shy-gal

Watson, Margeaux. "Caribbean Queen: Rihanna." *Entertainment Weekly* website. June 22, 2007. https://ew.com/article/2007/06/22/caribbean-queen-rihanna/

Diana Ross

"Diana Ross." Classic Motown website. Accessed August 2019. https://classic.motown.com/artist/diana-ross/

Hamilton, Jill. "Q&A: Diana Ross." *Rolling Stone* magazine website. November 13, 1997. https://www.rollingstone.com/music/music-news/qa-diana-ross-230900/

Kennedy, Gerrick D. "Commentary: On its 40th anniversary, a look at how 'The Wiz' forever changed black culture." *Los Angeles Times* website. October 24, 2018. https://www.latimes.com/entertainment/music/la-et-ms-the-wiz-40-anniversary-20181024-story.html

Kennedy, Gerrick D. "Q&A: Diana Ross on longevity and life off the stage." *Los Angeles Times* website. November 17, 2017. https://www.latimes.com/entertainment/music/la-et-ms-diana-ross-interview-20171116-htmlstory.html

Warhol, Andy. "New Again: Diana Ross." *Interview* magazine website. October 5, 2016. https://www.interviewmagazine.com/music/new-again-diana-ross

J.K. Rowling

J.K. Rowling website. Accessed August 2019. www.jkrowling.com

Text of J.K. Rowling's commencement speech at Harvard University. June 5, 2008. https://news.harvard.edu/gazette/story/2008/06/text-of-j-k-rowling-speech/

Nina Simone

Interview with Nina Simone. Released by the Estate of Nina Simone. Accessed August 2019. https://www.youtube.com/watch?v=c3ClwX7oyXk

Kelsey, Colleen. "Being Nina Simone." *Interview* magazine website. June 25, 2015. https://www.interviewmagazine.com/film/liz-garbus-what-happened-miss-simone

Nina Simone website. Accessed August 2019. https://www.ninasimone.com

"'The Real Nina Simone' 1968 Interview in Down Beat Magazine." Music Is My Sanctuary. February 14, 2014. https://www.musicismysanctuary.com/real-nina-simone-1968-interview-beat-magazine

Gloria Steinem

Kunhardt, Peter, director. *Gloria: In Her Own Words.* United States. HBO, 2011. 61 minutes.

Pogrebin, Abigail. "How Do You Spell Ms." *New York* magazine website. October 28, 2011. https://nymag.com/news/features/ms-magazine-2011-11/

Steinem, Gloria. "After Black Power, Women's Liberation." *New York* magazine website. April 4, 1969. https://nymag.com/news/politics/46802/

Steinem, Gloria. "The Moral Disarmament of Betty Coed." *Esquire* magazine website. September 1, 1962. https://classic.esquire.com/article/1962/9/1/betty-coed

Steinem, Gloria. "30th Anniversary Issue / Gloria Steinem: First Feminist." *New York* magazine website. April 6, 1998. https://nymag.com/nymetro/news/people/features/2438/

Meryl Streep

Longworth, Karina. *Anatomy of an Actor: Meryl Streep.* Phaidon Press, 2013.

Mottram, James. "Meryl Streep: Movies, Marriage, and Turning Sixty." The *Independent* website. January 24, 2009. https://www.independent.co.uk/news/people/profiles/meryl-streep-movies-marriage-and-turning-sixty-1488485.html

Streep, Meryl. The Golden Globe Awards, Cecil B. DeMille Award acceptance speech. 2017.

Tilda Swinton

Barnes, Henry. "SXSW 2014: Tilda Swinton on Derek Jarman: 'He wrapped the centre around him.'" The *Guardian* website. March 8, 2014. https://www.theguardian.com/film/2014/mar/08/sxsw-2014-tilda-swinton-derek-jarman

Hattenstone, Simon. "Winner takes it all." The *Guardian* website. November 21, 2008. https://www.theguardian.com/film/2008/nov/22/tilda-swinton-interview

Johnston, Trevor. "Virginia Territory." The *List* website. March 12, 1993. https://archive.list.co.uk/the-list/1993-03-12/10/

"Tilda Swinton: Wine and Poetry." *Interview* magazine website. May 11, 2009. https://www.interviewmagazine.com/film/tilda-swinton

Agnes Varda

Anderson, John. "Agnes Varda Is Dead at 90; Influential French New Wave Filmmaker." *The New York Times* website. March 29, 2019. https://www.nytimes.com/2019/03/29/obituaries/agnes-varda-dead.html

Emma Watson

Blair, Olivia. "5 Things to Know About 'HeForShe's' Latest Report on Gender Equality." *Elle* magazine website. September 20, 2017. https://www.elle.com/uk/life-and-culture/news/a38686/he-for-she-parity-report-gender-equality/

Emma Watson interviewed by Jessica Chastain. *Interview* magazine website. April 24, 2017. https://www.interviewmagazine.com/film/emma-watson-1

Emma Watson in conversation with Gloria Steinem. February 24, 2016. https://www.goodreads.com/videos/99192-emma-watson-in-conversation-with-gloria-steinem

"In Uruguay, UN Women Goodwill Ambassador Emma Watson urges women's political participation." United Nations website. September 18, 2014. https://news.un.org/en/story/2014/09/477712-uruguay-un-women-goodwill-ambassador-emma-watson-urges-womens-political

McGurk, Stuart. "How Emma Watson Is Taking Control." *GQ* magazine website. October 15, 2013. https://www.gq-magazine.co.uk/article/emma-watson-feminism

Speech by Emma Watson at United Nations Headquarters, New York. September 20, 2014. https://www.unwomen.org/en/news/stories/2014/9/emma-watson-gender-equality-is-your-issue-too

Serena Williams

Finn, Robin. "A Family Tradition at Age 14." *The New York Times* website. October 31, 1995. https://www.nytimes.com/1995/10/31/sports/tennis-a-family-tradition-at-age-14.html

Haskell, Rob. "Serena Williams on Motherhood, Marriage, and Making Her Comeback." *Vogue* magazine website. January 10, 2018. https://www.vogue.com/article/serena-williams-vogue-cover-interview-february-2018

Slater, Lydia. "Queen Serena: The Power and the Glory." *Harper's Bazaar* magazine website. May 30, 2018. https://www.harpersbazaar.com/uk/fashion/fashion-news/a20961002/serena-williams-july-issue-cover-shoot/

Sullian, John Jeremiah. "Venus and Serena Against the World." The *New York Times* website. August 23, 2012. https://www.nytimes.com/2012/08/26/magazine/venus-and-serena-against-the-world.html

Tignor, Steve. "Williams Forever: How Venus and Serena Changed the Game for Good." *Tennis* magazine website. March 12, 2018. https://www.tennis.com/pro-game/2018/03/how-much-venus-serena-have-changed-time-game-indian-wells-2001/72666/

Amy Winehouse

Kapadia, Asif, director. *Amy.* A24. July 16, 2015.

Sandall, Robert. "Can Amy Winehouse be saved?" The *Sunday Times* website. July 27, 2008. https://web.archive.org/web/20081007024633/http://entertainment.timesonline.co.uk/tol/arts_and_entertainment/music/article4383952.ece

Oprah Winfrey

Oprah Winfrey biography. Academy of Achievement website. Accessed August 2019. https://www.achievement.org/achiever/oprah-winfrey/

Trevor Noah interviews Oprah Winfrey. *The Daily Show.* Comedy Central. April 10, 2019. https://www.cc.com/video-clips/547gj1/the-daily-show-with-trevor-noah-oprah-winfrey----the-path-made-clear----using-her-platform-as-a-force-for-good---extended-interview

"'Watching Oprah' Exhibition Opens at National Museum of African American History and Culture June 8." National Museum of African American History and Culture website. June 6, 2018. https://nmaahc.si.edu/about/news/%E2%80%9Cwatching-oprah%E2%80%9D-exhibition-opens-national-museum-african-american-history-and-culture

Anna Wintour

Craven, Jo. "Anna Wintour." *Vogue* UK website. April 22, 2008. https://www.vogue.co.uk/article/anna-wintour-biography

Scott, Fiona Sinclair, writer. Christiane Amanpour interviews Anna Wintour. CNN online. April 9, 2019. https://www.cnn.com/style/article/anna-wintour-interview/index.html

Wintour, Anna. "Honoring the 120th Anniversary: Anna Wintour Shares Her *Vogue* Story." *Vogue* magazine website. August 14, 2012. https://www.vogue.com/article/anna-wintour-on-her-first-vogue-cover-plus-a-slideshow-of-her-favorite-images-in-vogue

Malala Yousafzai

Malala Fund website. Accessed August 2019. https://www.malala.org/malalas-story

The Nobel Prize website. Accessed August 2019. https://www.nobelprize.org/prizes/peace/2014/yousafzai/facts/ https://www.nobelprize.org/prizes/peace/2014/yousafzai/26074-malala-yousafzai-nobel-lecture-2014/

Trevor Noah interviews Malala Yousafzai. *The Daily Show.* Comedy Central. October 10, 2013. https://www.youtube.com/watch?v=gjGL6YY6oMs

ICONS
Illustrated by Monica Ahanonu
Written by Micaela Heekin

Editor and Art Director: Gloria Fowler
Design and Production: Kayleigh Jankowski
Copy Editor: Emily K. Wolman

ISBN: 978-1-7972-0135-1
Library of Congress Cataloging-in-Publication Data available.

Manufactured in China

CHRONICLE CHROMA

Chronicle Chroma is an imprint of Chronicle Books
Los Angeles, California

chroniclechroma.com